"Mary Kurek has created a unique and easily implemented system for effectively organizing and utilizing your network of business contacts. Loaded with suggestions for identifying and then filling in the gaps in your network, Kurek's book is a 'must' for entrepreneurs and professional women who recognize the importance of a dynamic network."

Carolyn Elman
CEO, American Business Women's Association (ABWA)

"*Who's Hiding in Your Address Book?* is the bible for how to comprehensively arrange your network system to create miraculous results and increase profitability."

Jill Lublin
Author of the bestsellers: *Guerrilla Publicity* and *Networking Magic*

"Throughout our country, in survey after survey, we discover that one of the top three reasons a business joins their local chamber of commerce is for the opportunity to network and develop new business contacts. In *Who's Hiding in Your Address Book?*, Mary Kurek explains in simple, easy to understand language, how to expand and enhance your business network. A must-read for all networkers!"

Chuck Ewart, Certified Chamber Executive,
Faculty Member, U.S. Chamber's Institute for Organization
Management

"Networking is both an art and a science, and Mary Kurek approaches it from both angles. Her book *Who's Hiding in Your Address Book?* is an outstanding resource. Don't put it on your bookshelf; keep it within arm's reach. We plan to make this book 'required reading' for all the business people who participate in our Chamber's Leadership program every year."

Mike Wagoner, President
Carteret County Chamber of Commerce

"This is the best book I've ever seen on strategic, lucrative networking. Kurek writes with precision and enthusiasm, and I can't imagine any seeker of success not being boosted to the next level by this powerful system."

Steve Chandler
Author of *The Small Business Millionaire*

"*Who's Hiding in Your Address Book?* is a must for your business library. The specificity of her tips and examples will ensure your success."

Jane Pollak
Author of *Soul Proprietor: 101 Lessons from a Lifestyle Entrepreneur*

"*Who's Hiding in Your Address Book?* is brilliant. I never knew what to do with all those business cards I gathered at networking events. Now, I am making the best connections I need to move my business forward quickly."

Randy Peyser
Author of *Crappy to Happy, Miracle Thinking* and *Visionary Women Inspiring the World*

WHO'S HIDING
IN YOUR
ADDRESS BOOK?

Introducing
The Ideal Network
for Successful Women

by
Mary Kurek

Robert D. Reed Publishers • Bandon, OR

Copyright © 2007 by Mary Kurek

All rights reserved.

Robert D. Reed Publishers
P.O. Box 1992
Bandon, OR 97411
Phone: 541-347-9882 • Fax: -9883
E-mail: 4bobreed@msn.com
web site: www.rdrpublishers.com

Editors: **Linda Jay Geldens, Beth DeMarco**, and **Cleone Lyvonne**
Cover: **Cleone Lyvonne**
Photographer: **Gayle Kinsella**
Typesetter: **Barbara Kruger**

ISBN 978-1-931741-87-3

Library of Congress Control Number 2007924723

Manufactured, typeset and printed in the United States of America

To my mother, Janice Lee,
for helping me to make this book possible,
and for her unwavering support and love
through all of my creative pursuits

Acknowledgments

I'm always telling my clients that they'll never accomplish anything significant all alone. It takes a force of *ideal* people to pull off dreams. My "force" begins with my own captain—Capt. John Kurek, USMC, Ret., my husband. Though, I'm pretty sure he didn't fully understand what I was doing at the computer night and day, he couldn't have been more supportive and proud. In fact, my entire family, to include my in-laws and granddaughter, Bella, makes up my cheerleading squad. And, I'm so grateful! Special appreciation, for their pats-on-the-back, goes to my children, Tommy, Carey, and Jana, as well as my Grandma Mary. With my mother at the helm, this is a mighty force of support. Speaking of family, I wish to make particular mention of the contributions of graphic expertise and advice by my talented sister-in-law, Cindy Lee.

A great family support system is important, but when you have good friends who jump at the chance to share your joy and keep you motivated, then you are truly blessed. Many thanks to Linda Bunn, Gayle and Jack Kinsella (Gayle took the photo for the cover), Margaret Harvey, Irene Zaccardelli, Darlene Holdiman, Robin Hamm, and Connie Nelson.

Among those people who helped to breathe life into this project, are a group of people I'll call "story-providers." These are the folks who allowed me to tell their successes, failures and mishaps to add interest and evidence to the book. Thanks to Jay Conner, Tracy Williams, Licia Felton, Linda Staunch, Jeff Kurtz, Llew Ramsey and Elaine Main of The Selling Team, Hamilton Nobles, Dr. Kay Flakes, Keri Patterson, Dr. Jonathan Elion (on behalf of Gertrude Elion), and Mary Manin Morrissey. Mary's story, in particular, was an exceptional contribution, and I cannot thank her enough for her candor and inspiration.

In addition to my story-providers, there were those people who allowed me to use their quotes, mention their organizations or extract from their publications. I'd like to express special thanks to Angela, P.R. Department at Harpo, Rey Carr of Peer Resources, and the following organizations: Women's Sports Foundation, Mary Kay Cosmetics, Business and Professional Women, American Business Women's Association, and the NC Journal for Women.

There are four women who became an integral part of this book via their participation in a test-run for The Ideal Network System. The women that make up The Ideal Network Club in this book are a special group. Debbie Fisher, Julie Naegelen, Tressa Taylor, and Martha Vaughan started out as individual businesswomen who belonged to the local Chamber of Commerce. They (I should say "we") bonded quickly and became active friends who are supporting each other's efforts. I'm so thrilled that they formed The Ideal Network Pilot group, and that they allowed me to share their stories with you.

The Ideal Network Club would not have evolved if not for the initial efforts of Julie Naegelen, who is the Manager of Membership Services at the Carteret County Chamber of Commerce located in Morehead City, N.C. Her efforts, combined with those of Chamber President, Mike Wagoner, gave the club life…and a home. They are the primary reason The Ideal Network Club can be presented as an opportunity for other Chambers of Commerce. Thanks so much to the Carteret Chamber and their fabulous staff.

People who step forward and endorse your work are just "Godsends." Their words add weight and meaning to whatever it is that you are trying to get off of the ground. I am humbled to have such incredible authors, speakers, and professional leaders acknowledge my efforts. My heartfelt gratitude goes to them for their generosity.

Since this book is about setting up an *ideal* network, it should be no surprise that I would have an *ideal* group of mentors, advisors, and service-providers. Randy Peyser of Author One Stop was my Author Coach and filled the immense gaps for me about writing a proper manuscript and book proposal. Her guidance and

connections advanced this book by leaps and bounds. Karen York of Two Dots Permissions did a quick and excellent job of checking the manuscript for permissions needs. I want to also mention Linda Jay Geldens, my copyeditor, whose sharp eye and patience made a painful job a lot less difficult. Additional editing assistance provided by Beth DeMarco rounds out a support team that would make any writer feel like a genius. I extend much gratitude to them all, for I know they had their work cut out for them.

I feel so fortunate to have Robert D. Reed Publishers deliver "my baby" to you. I appreciate so much their gentle guidance and wonderful ideas. Many thanks to Bob, himself, who "believed" and to Barbara Kruger, whose talent as a typesetter gave form to this book. The primary tasks associated with getting this book ready fell to the vibrant and multitalented Cleone, whose attention to her authors makes her invaluable. What a gift she has been.

This is my force of people—and while I'd like to claim that I had everything to do with coordinating them, I know this particular task was performed by a higher power. My prayers of thanks go to Him daily…with an added sincere note of appreciation to you, the recipient of this work.

Contents

Foreword

I wish I had Mary Kurek's book, *Who's Hiding in Your Address Book?* twenty years ago when I was starting out as a young entrepreneur. After two failed businesses, I started a bag printing company with my best friend, Sheryl Felice, in 1988. We were printing paper and plastic shopping bags for businesses. We went from having no customers to producing large orders for trophy clients that included Disney, Nissan, Warner Brothers, Mattel, Ocean Spray, and Sears. What was the difference between the failed businesses and the successful business? I built my network, harvested the relationships, and got over my fear of asking for help.

By using Mary Kurek's *Ideal Network System*, I became known as the "Wealthy Bag Lady". Using the power of the relationships I created by dealing with thousands of clients, I started a consulting business. Then everyone told me to write a book. Again, with the power of the *Ideal Network System*, my book went from total obscurity to the #1 best-seller on the Amazon.com Entrepreneurship List.

I interviewed the top CEOs and multi-millionaires to get their business advice. The commonality of all the successful business owners is the strength of their network. One of the top CEOs told me that without his support team, he would probably be flipping burgers somewhere.

Mary Kurek's *Ideal Network System* teaches you that you need a cadre of different types of people in your network: mentors, media, and connectors. I tend to be impatient, so I love the fact that the system can be done quickly without lots of time and money invested.

What if you're shy? Even though I've spoken to thousands of people as an entrepreneur, speaker, and author, I came from a

painfully shy background. Growing up, I hardly talked to anyone. The thought of introducing myself to a group of strangers at a networking event terrified me. Now I know that most people think of themselves as shy. They really appreciate it when you approach them and introduce yourself. I've developed the most amazing contacts in my network this way. The strategies in *Who's Hiding in Your Address Book?* will take the fear out of networking and help you skyrocket your business.

Mary knows that the pot of gold in your business lies in your network. Remember, that nobody succeeds alone. Behind your success story, you will find many people who supported you and held your visions in light.

Mary Kurek is one of the greatest gifts to walk this earth. Read her book and reap!

Linda Hollander

Linda Hollander
Wealthy Bag Lady
Author of *Bags to Riches* and
Founder of the Women's Small Business Expo

Introduction

Every day, each of us totes around an entire company of talented, skilled and experienced "staff," although we do not know it. Referred to as a network, their names and contact information are generally kept in our address books, PDAs, or day planners. However, other than their professions and perhaps a hobby, we know almost nothing about the individuals whom we have met at a conference or luncheon. And what about all those business cards we've collected? Don't they just wind up being shuffled into our database where each person then becomes the target for our e-mail newsletter that they might never wanted to receive in the first place?

By not knowing how to effectively categorize and utilize the individual connections in an expanding network, you are being robbed of a goldmine of income, expertise, and support to help your businesses grow or to achieve whatever goal you desire. As a businesswoman, you want success, and not having every possible asset to create that success is simply unthinkable.

In this book, you will be introduced to The Ideal Network System, which will show you how to re-categorize your network to use each person as a particular resource who can move you closer to the achievement of your goals. In essence, The Ideal Network System unveils the staff that has been hiding behind the letters of the alphabet in your address book, and provides an easy-to-use system to make the connections you need to make things happen.

If you want to launch a new business or expand your client base, there is a gap between where you are and what you wish to achieve. The solution for closing that gap is *connection*, but not just any connection. To get *ideal* results, one must have *ideal* connections. When we need an attorney or a mechanic, we call one. They are easy to find because they are listed in the phone book

under the service they provide. Now, what if you need someone to help you identify potential clients? Service-providers like that aren't easily discovered in the Yellow Pages—but they are in the *ideal network.*

What would happen if, instead of thinking of your network as just an address book of names, you thought of it as a complete staff, organized by position? You may not know it, but if you have five people in your address book, you have five "staff" members—and one of those five people is going to be the connection you need to help you with what you are working on right now! Why is this important to know? Because, literally, each big or small success we manage in our lives is a result of a connection with another human being. It's the reason the personnel department of every business is called Human Resources. If a fully functioning business needs people filling specific job descriptions in order to be successful, surely you can see that you do, too. But here's the good news…you already have the human resources, you just need to know how to organize and utilize them. They're all right there in your network, waiting to help you master the extraordinary success that is now within reach.

In this book, I will guide you through a review and reconstruction of your current network, so that you view your contacts in a more user-friendly way. You will use a simple method I call "connect-a-name" to open up possibilities and grow your network, resulting in a stronger base that will enable you to create phenomenal results. Additionally, you will find tips and action steps to help you utilize and manage your new network, as well as inspirational stories. You have the best ideas, and now you can have the best "staff" to bring those ideas to reality.

A network is simply a group of people connected by one common reason, one entity, or one person. As you read this book, consider the many networks in which you are already involved. There are accessible networks and fabulous connections around you, if you look for them. For example, every non-profit or membership-based organization is a network. Your child's soccer team, the local Rotary Club, your bank, book club, and the neighborhood in which you live are networks. You are networking every time you attend a PTA meeting, call your friends to set up

lunch, organize a birthday party for your child, or carpool to work. You network every day in a dozen different ways, because this is the most effective way to get things done. Networking is natural and vital to the operation of life. But, because most of your connections are made casually through the course of daily tasks, you may not view the people in your life as being the most valuable resource you have.

Networks can be seriously dynamic machines. They can cause laws to be changed, impact election results, raise millions of dollars to aid whole countries, and rebuild stricken communities. No matter how seemingly impossible the goal, the right network with the right leadership can produce absolutely amazing results. In 1890, four women with the same cause yet very different platforms united two organizations to form The National American Woman Suffrage Association, known as NAWSA. Elizabeth Cady Stanton, Susan B. Anthony, Lucy Stone, and Julia Ward Howe provided leadership that would inspire women like Carrie Chapman Catt, whose political intelligence gained her the presidency of NAWSA. Alice Paul brought her own brand of fearless activism to the forefront and created the National Woman's Party.

Each of these women individually, their successors, followers, and supporters were the rightful claimants of victory on August 26, 1920. On that day, the Nineteenth Amendment granted the ballot to American women, making some twenty-six million women immediately eligible to vote—an impressive story, but even more so when you consider it took fifty-seven years and hundreds of campaigns to accomplish this mission. The majority of women who made up this enormous network came from many smaller networks, such as women's clubs and trade leagues all across the country. For some, the experience of involvement in a powerful network prompted other efforts to mobilize women. For example, The National Federation of Business and Professional Women was created in 1919 and remains a respected and vital voice for women to this day.

The indomitable Mary Kay Ash knew the incredible power of a network firsthand. With only $5,000 and a huge passion to empower women, she created one of the best companies to work for in America, according to Fortune magazine. What Ms. Ash did

to build her worldwide billion-dollar organization has become the model for practically every direct sales business since. Even if you dream big, you must begin, like Mary Kay Ash, with the network you have in place. She started with just nine beauty consultants. It is currently reported that the company has more than 1.6 million consultants; each one of them relying on their networks to help them succeed in business.

I'm not saying this book is about you going out and changing the world, but I do believe that you not only have the right to fulfill the vision you hold for yourself, you also possess the requirement. The good connections that you make while moving toward your goals will produce fantastic energy that will extend far beyond you and your own success. You are already a contributor to someone else's success, whether you know it or not. Perhaps a referral or idea you have passed along has made a difference to someone's livelihood. Whatever it is that you offered has secured you a "staff" position in that person's network. You are participating in a circle of support every time you lend assistance. As you provide advice, contacts or information, others are providing the same to you.

The point is that good connections actually do change the world. What you need to do is to open yourself to a new way of working with your connections and then allow life-changing things to happen. By implementing The Ideal Network System, you will make more meaningful connections and achieve faster results for the goals you set. The shift in how you view your people resources can translate into more clients, smoother business operations, increased visibility, and more productive collaborations. You will have stronger relationships, a quickly expanding network, and more of your projects will reach fruition. Let me put it another way…you will experience less struggle and frustration—no matter what you are trying to accomplish. You deserve that, because what you wish for is available, whether it is a great idea to spark new business or a personal dream. I know this as surely as I am convinced that you already have what it is that you need to create the success you desire. This is the journey that I will take you on. So, let's get ready to find out *who's hiding in your address book.*

Readers: Thank you for buying my book. As my gift to you, I'm giving you a free year's membership into The Ideal Network Club (a $125 value). Visit www.theidealnetworksystem.com/reader to register your membership and sign up for your free "Ideal Network System Quick-Start" Teleseminar (available only to members).

Chapter 1

AN IDEAL NETWORK SHOULD PRODUCE THE "IMPOSSIBLE"

Who would expect that a successful business owner would have the time to play the piano, much less become an accomplished composer? But, my friend Jay became such a good musician that he eventually produced a couple of CDs. Although well received, it seemed Jay's audience would remain local until something happened—an *ideal* connection. As it happened, someone in Jay's network sent a copy of his CD to someone in his network...in Hollywood. That Hollywood connection was a prominent screenwriter who was selecting original music for a film. After reviewing an avalanche of submissions (9,200 to be exact), Jay was offered a contract for one of his compositions to be included on the sound track of a major motion picture. This is proof positive that the word "impossible" just doesn't exist if you have an *ideal* network.

When your goal is to create success in your business, you may wonder why it is necessary to have a network that can rock the world. Obviously, manifesting one's desires has many requirements beyond having a great group of people in your network. For starters, your intentions must be clear. But, unless you plan to handle every aspect of your business alone and use psychic powers to attract clients or connections, you're going to need people...really good people in your network.

As a former Executive Director for a Chamber of Commerce in North Carolina, I've spent many hours coaching new business

owners on how to collaborate with other businesses and individuals. Entrepreneurs who think they can "go it alone" will have a tremendously difficult time. If you think you can "make it" without creating an *ideal network*, you are cheating yourself out of the possibility of even greater success. Worse, you are lessening your chances of a full recovery when your business has problems…and every business eventually has problems.

It really doesn't matter if you're starting a graphic design business or shooting for a spot on the PGA; it all revolves around putting something important inside of you—"out there" to be consumed. The desire to succeed comes from your heart, and because each individual's desire is so personal, the people who help you make the connections to success should be considered nothing less than miracle workers.

As a young boy, Tracy A. Williams, for example, moved from New York City to a small historic harbor village in North Carolina. The transition forced Tracy to focus on something that would keep him busy. That something was basketball, and it became the reason Tracy would wake up in the morning. By the time he was a junior in high school, Tracy had made a name for himself locally as a star player, but that wasn't enough to get him into college. His high school guidance counselor finally provided the bridge. She worked with Tracy, kept a scrapbook of his best games, and wrote over 100 letters to colleges recommending him for an athletic scholarship.

As a result, Tracy became one of the most-recruited young athletes in eastern North Carolina. The scholarship came, as did a career in professional basketball, including a contract with the world-famous Harlem Globetrotters.

Tracy's current bio contains acting credits for an ESPN commercial, a couple of major motion pictures, and a popular teen television show. But he's most passionate about his motivational speaking program for at-risk students. To accomplish all of this, Tracy has a pretty awesome network, but it all started with one incredible connection—that counselor who pulled out the stops to help this street-kid get on track.

Just as Tracy was helped by his own personal "guardian," the *ideal network* will provide more for you than can imagine for yourself. Wouldn't you just love to have someone working as hard

as or harder than you are to make your dreams come true? The reality is that you really can't buy that kind of devotion. In the story above, you might say that Tracy got lucky by having a counselor willing to go the extra mile for him. He'd tell you that she was his "angel," but in Tracy's network, you'll find other angels, like the one woman who connected him with a talent agent and casting director. And then there's the professional speaker who mentored him to develop his own speaking career. It's not luck that got Tracy this far. Tracy has an ability to attract the best connections in his network...the ones that can perform magic. How does he do this? The clue lies in attention.

People tend to respond to those who pay attention to them. You cannot help but feel drawn to someone who can totally focus on you and who cares about you. Even if the two of you are very different people, an understanding will evolve and a mutually supportive framework will move into place. You may not even make contact with one another for weeks or even months, but when you do connect again, you'll find yourself immediately championing that person's interests. More than that, you will call him or her when you hear of perfect opportunities or valuable information, and they will do the same for you.

The ability to make people feel important and personally involved is special...and something Tracy does naturally. I should know; I'm included in his network...one of those people he refers to as his "angels." But, if these little cherubic-faced helpers aren't flocking around you, here are some quick tips that will enhance your ability to naturally attract people to you:

- Make regular eye contact.

- Listen more than you talk, and do so with genuine interest.

- Ask questions that have more to do with the person than with outside events.

- Thank the person from the heart for anything he or she may share with you.

- Should the person make a successful connection for you, give him or her credit...publicly when appropriate (very important).

- Your goal should be to make that person feel supported (and applauded, if possible) by the end of the connection.
- Be responsive whenever this person attempts contact with you.
- And always, always offer to make introductions or connections where it will benefit the other person.

So now you know that having the "dream team" network will advance you faster and easier toward accomplishing your goals. You also know that attracting these special helpers requires being super-attentive to people who come into your life. But what you may not know is that you probably have at least one or two of these "gems" already in your current network. Yes, even if you are less than charming…and even though you don't yet have the *ideal network*, somewhere in your life is at least one person who has the capability to help you take a step toward whatever it is you wish to accomplish right now.

There is a popular school of thought that centers around our unconscious abilities to draw toward us exactly what or who we need. Who you need may not be easily recognizable as your fairy godmother, however. He or she may be a rather vague connection that you made years ago. Perhaps someone passed along the name of a person you never contacted. Or (and this is most probable), because you really don't know your network or are not "working" it like you should, someone you think you know is sitting there holding the keys to your success without realizing your need. That elusive "genie in a bottle" is hidden in your weekly planner or in a basket of business cards from an event, and all you have to do is ask.

In my particular niche as a personal coach and consultant, I help people market their talents or transition their careers. For all intents and purposes, I am a professional networker. For clients who are stuck, I routinely help them comb their networks to find that special contact that moves them forward. Sometimes this means interviewing them about the various types of people they know. Occasionally, it means having the client perform a "mini e-mail campaign" that has them identify (with specifics) the type of person

or situation they want to attract. Then, they e-mail a simple request to their network to ask for help in finding and making that connection—the more specific the request, the more amazing the results.

As with every connection, when you try this technique, always offer to return the favor. With the investment of as little time as it takes to e-mail a handful of people, I find this "campaign" to be the quickest and most effective means of mining your network for exactly what you need.

Here's how I conducted my first experiment with the mini e-mail campaign: Over the course of two days, I e-mailed or faxed twenty-two people in my current network. I told them I was expanding my network and asked them to look through their address books for people they thought I should know. I was clear about what type of people I wanted to attract for this experiment, and I listed a few qualities of the kind of people I was looking for— successful, motivated, open, and people-oriented. In some cases, I was specific as to the type of industry contacts I was looking for.

Within ten days, I had fourteen responses. Out of the fourteen responses, I received eleven names and phone numbers, and a marketing tip (which I used.) The quality of the new contacts I received was just unbelievable. One was a writer/producer/director who had a son in the film business in Los Angeles. I was also given the son's phone number. I was introduced to an entrepreneur, two former New York Giants players, an executive for a statewide non-profit organization, an author/speaker/radio show host, a cameraman for a Warner Brothers television show, a film publicist from New York City, the manager for a recording artist, and a public relations specialist for a major television network. I followed up with phone conversations or lunch with most of these folks, and we swapped valuable business information.

During this time, I further attracted a variety of wonderful new connections and opportunities, including: an inquiry to serve on a local board of directors for a non-profit; another inquiry to serve on a town government committee, a special guest for my local television show, two new personal coaching colleagues, an invitation to attend an event hosted by a dynamic philanthropist whom I had been trying to get to know, and a request from a

facilitator of a corporate training program to use my networking system and materials for his classes.

Some of the things that occurred were a direct result of the requests I'd made during my mini e-mail campaign, while others were a side result. Regardless, there seemed to be a whirlwind effect that was generated from my having blasted off those initial inquiries and juicing the creativity of several contacts from my network at once. It was as if I had revved an engine that had been sitting idle. I have done the mini e-mail campaign for myself several times and the whirlwind effect is always present. You should try this for yourself.

Finding the best person to help you get closer to your dream or goal, whether this person is currently in your life or not, can still seem daunting, but once you're serious about the search, results can be instantaneous. For example, one time, I reviewed a client's address book with him over the phone and, within minutes and much to his surprise, uncovered a great next-step contact for him that allowed him to advance his writing career.

For another client, after talking about her community involvements, we determined that a particular member of her church would be the best connection to help advance her music career. That connection led to another, which resulted in her debut at a major public event and an opportunity to perform with some popular artists. The *ideal* connection for her was someone she saw on a weekly basis from a distance. She even had a feeling he might be a good contact; however, she hadn't yet identified him as someone who might be valuable to her in her network.

Here's another example of how nearly invisible contacts can become invaluable. My friend Licia was so moved by an experience she had one day when she came into contact with a family living out of their car that she decided to someday build a homeless shelter. It turned out that her younger brother Levar would be the one to help Licia begin the process of making her dream come true. When he secured a contract to play professional football, he talked with his family about doing something to give back to the community. It was the opportunity Licia Felton was looking for. A foundation was organized and the plan for a homeless shelter began to inch forward.

But that's just the beginning of the story. About a year later, Licia's parents lost their home during Hurricane Floyd, causing Licia's focus to shift from fundraising to helping her family. Then Licia suffered a sudden loss of her own home, which forced her to move her family of five into a small motel room. Feeling stalled, helpless, and homeless herself, she clung to faith and hoped for a miracle to reactivate the dream.

The miracle turned out to be in the form of an employee of an existing shelter that was on the verge of closing down. This employee actually called Licia once in a while informing her of the difficulties at the shelter. She was already in Licia's network, but almost completely hidden by the heavy burdens Licia was shouldering. The burdens lifted quickly when action was finally taken on the information that allowed Licia's foundation to assume management of the failing shelter. At the same time, a home became available that was just right for Licia and her family.

The kind of network that can pull light out of the darkness is exactly what Licia needed to rekindle her heart's desire. This reversal of conditions happened almost as suddenly as the disasters had occurred, and the miracles all began with Licia's faith and a "not-so-obvious" *ideal* connection from her own network.

By now, you should be wondering about all those people with whom you've served on committees or have sat next to on an airplane. But, before you start digging through your stuff and creating a big headache for yourself, read on. The chapters ahead will help you get to the heart of your current network and develop it into something that will be easy for you to use…and completely awesome.

Chapter 2

THE TRUTH ABOUT YOUR CURRENT NETWORK

Without even knowing you, I can tell you some truths about your current network. For starters, it isn't substantial enough to accomplish everything that you want. Next, your address book is most likely filled with people who are a lot like you. Another truth is that you are carrying a good bit of "deadwood." Although not the best label to apply to human beings, it accurately describes the contacts that you haven't used in years or people with whom you have no real relationship. Most everyone has deadwood in her address books. It's hard culling out people who, for whatever reason, found their way into our lives. And, although simply removing their name and phone number out of our registry isn't really erasing them…the symbolism clearly makes it feel that way.

Here's another truth…you are not even completely aware of the real reason why you have the people that you do in your network. Understand that what I'm saying is simple: every person who exists in your life has a purpose for being there. Family members and service providers aside, everyone else is in your database for reasons that go beyond the general or occupational category you have assigned them. Those very specific reasons are the foundation for your new *ideal network*.

"Never apologize for showing feeling.
When you do so, you apologize for the truth."
– Benjamin Disraeli…Prime Minister of England 1868, 1874-80

Truth will be the new basis for putting together and operating your *ideal network*. That may sound strange right now, but the reason will become clear as you answer the question "why" for each person you include. However, before we launch that particular attack, let's address your method of management.

Most people have their network in alphabetical order in a database, address book, or high-tech device. I'm going to ask that you pull out that address book and actually make a photocopy of it, or print out a hard copy of your electronic listing. Don't worry— I'm not asking you to dump your current method. What you are about to do is create a new, unique tool of management that will be kept separately and privately. You just need to trust me here. This new method has everything to do with the sincerity that lies in your connections. The challenge to you is to open up to a new way of handling your people resources.

Now, let's get to the first task. Get yourself a nice, big, fat, red marker. We're going after that deadwood. As you look at the names on the copy that I asked you to make of your address book, cross out the names of those people with whom you have not had contact inside of three years. I'm assuming that if you have not made connection in that period, there is no real ongoing relationship. There is not enough frequency of communication for growth or synergy to happen. There is one exception I have for deadwood— keep on your list any decision makers or experts whom you feel reasonably certain you will need in the future. I define decision makers as people in a position to make things happen in their industry. Experts are people with a high degree of knowledge and resources in fields of interest to you.

I know what you are thinking here. What if someone in my deadwood pile could in fact be that incredible connection that I need? My answer is that you are engaged in the task of building a network from which you will make powerful requests and expect powerful results. And, you will be participating as well, because networking is reciprocal. An *ideal network* also brings you unexpected value every now and again, but mostly, your communications with the group will be purposeful. This is why you need to have enough of a relationship with the people on your list to be comfortable interacting with them. You should also have

some idea of how you utilize them. Even though you will be adding some "fresh blood" (new relationships) to the mix, people who are more a part of your past than your present may be better to keep on your alphabetical list. Having said all of this, don't worry or dwell too long on making the choice of whether or not to include someone. Constructing an *ideal network* is important, but leaning a bit toward inclusion certainly isn't going to cause problems.

Family is a tricky topic for some when it comes to connecting for the purpose of making requests. We generally shy away from requesting favors of immediate family for fear of judgment, or the perceived negatives that are attached to doing business with someone that close. If you have family members with particular skills, special expertise, or funding abilities that could be useful to you, include them in your new network.

Next, let's address your personal Service Providers. These are the people you need to help you stay groomed and healthy, and to manage some of the mundane and technical aspects of your daily life. Make sure their contact information is updated and keep them in your alphabetical listings. The same goes for anyone whose information you need to keep for reference, such as those who serve on a committee or board with you, referred to as Community Associates.

Are you a caregiver? I have a special note for primary caregivers, or those of you who manage information or contacts for others: In my particular case, I am responsible for handling administrative matters for an elderly family member. For this person, I have created a separate list of doctors and contacts that I have identified as her "team." This list is composed of a two-sided page that slides into a clear plastic sleeve. It is kept in a visible location on my desk where it is particularly handy if I need it for a meeting or when I find myself having to make quick phone calls.

CREATING YOUR IDEAL NETWORK MINDSET

Up until now, everything you've done has been about weeding and updating. Now the real process of creating your *ideal network* is about to begin.

To make the necessary shift to think of your connections in a new way, you should understand the importance of focusing during

your networking activities. If you don't really comprehend what people tell you about themselves, you won't have the most complete information to make the best connections. You need to listen and ask good dialogue questions. Here are some examples:

- What's happening with your latest project?
- Who exciting have you met lately?
- Is there anything I can do to be of help to you in what you are working on right now?
- What's on your plate for next week?

Ask open questions that elicit conversation, steering clear of questions that only get you a "yes" or "no" answer. Commit important items to memory during moments of communication.

Since I cannot consistently rely on my recall ability, I keep a notepad in my purse and also in my car to jot down bits of information about people I've just met. If a person has given me a business card, I'll jot my notes on the back of the card, including the date and the occasion of the meeting. I know some people who use their cell phones to record notes. Doing so helps to keep memory lapses from erasing a connection.

Your ability to recall what people tell you and ask you, and how you felt about a meeting, is important for making good choices in organizing and utilizing your network. Whatever you can do to create additional thoughts after meeting someone you'd consider a potential network member is critical. For example, write a follow-up note, keep their business card visible for a few days afterward, or mention their name to another contact. Doing so will help to reinforce that person's position in your memory and your network.

Creating the *ideal network* mindset is really a matter of training yourself to think of your networking connections as though each connection is like a small business meeting. Even if most of your networking takes place in informal settings, you need to operate from a position of seeking to get a true sense of each person you meet. Of course you'll be interested in what they do for a living, but what you really want to know lies beyond their job title. Who is the person behind the bio? Later, when you are considering them for

your *ideal network*, you want to remember who they are and how you experienced your exchange with them.

When you are structuring your *ideal network*, some honest thought should be applied. Unlike jotting a name under a letter of the alphabet, your new network will be made up of people who, for lack of a better term, hold positions in your life. How you will place them in your network will not necessarily be based on their occupation or how important their friendship is to you. We're talking about emotional connections versus factual reasons.

Pretend the person is applying for a position with you. The resume attracts you, but it is in the interview that you discover what qualities you really need to be able to utilize the person. The names in your current network, and new ones to come, are candidates that will be placed in your network according to your truthful answer to the question "why"—as in "Why do I keep this person's name and phone number?" By investing some thought, you'll get to that answer. Your memory will serve you better when the time comes to find that perfect link to the newspaper interview you want or the new business endorsement you need. Thought will make every connection seem effortless.

Now it's time to get busy reconstructing your *ideal network*. I'll divide the process into manageable steps and give examples that I think will help you. We'll start with the people you call friends.

Step 1

Get out your hard copy list of contacts again—the one that you marked up during our deadwood cleanup. Clip out the names of five or six friends and put them in front of you. Have paper and a pen handy.

Step 2

Consider each name carefully, listing on a piece of paper why each of those friends occupies space in your life. I'm sure that at least several ideas will come to mind as to why you are attracted to them, but you must think beyond your shared hobbies and occupations. Every good friend provides us with something important that we need. What you are aiming for is to discover specifically what that person adds to your life. You'll note these reasons with one or two words that describe their unique roles in

your life. Those well-chosen words will now become categories in your *ideal network*.

Example: You may be inclined to write down that one friend is in your life because he provides unconditional support, when really what he does is solve problems for you. His ability to problem-solve might be his primary contribution to you, and you may find yourself relying on him mostly for this one particular gift. Simultaneously, you might find it hard to acknowledge on paper that his primary purpose is to solve problems for you. Please understand that we're all human beings, and sometimes we are attracted to people for reasons that maybe aren't what we'd care to admit. Put aside your ego so that you can be really honest with yourself.

Example: Here's my own little story about getting the ego out of the way. When I reviewed my friends, I was surprised to find that I had several people in my network because I was attracted to "celebrities." I can't help it—it's the truth. These are people who hadn't necessarily made it to stardom, but each one had reached a high level of public admiration, visibility, and success. The fact that this piece of information about me came to light didn't diminish my friendship with them, since I felt as useful to them in their networks as they were in mine.

It took me a while to get down to this realization and actually write the word "Celebrity" on paper. Oddly, I discovered that "Celebrity" was a rather large category in my network. I've gotten over my initial embarrassment because I know what we can do and have done for each other, and I know that these are people who have wonderful hearts and goals. We have created brilliance before, and now, because I have invested some thought and placed them under the right "why," any magic I might want to create with them in the future will come much easier.

Step 3

As the categories become evident, write each on a single piece of paper and place the clipped name of your friend that fits on top. You may find that you have other friends that fit the same category.

That's fine. You may also feel strongly that you have several friends that fit in more than one category—so add them to other categories as you like.

For example, if you think of a friend only as a friend, you are limiting the relationship and overlooking other very good reasons as to why they may have shown up in your life.

Consider this example: My friend Linda Staunch is a total dynamo. Her energy and drive would put most women to shame. It was this energy and her success as a businesswoman that drew my attention. Our first lunch meeting was at my request, with the hope that I'd discover what made this woman so special. It was the beginning of a solid friendship, and now the two of us meet occasionally to discuss each other's projects and plans. Always amazed by her expertise and style, I often refer to Linda as a mentor.

One day when I was presented an opportunity do business with a new client, I began searching for information on how to set fees. The work was unusual, which made the task of setting up a contract challenging. Frustrated after many fruitless hours researching the Internet for help, I turned to my (alphabetically organized) network and e-mailed the only person I thought would be able to help, but even he had no advice.

While looking over the names in my address book, I stumbled across Linda, the "dynamo." It occurred to me that she was a friend I hadn't seen in a while. Over coffee, we began to chat about projects, just as we usually did. Within ten minutes, however, she delivered the advice I was seeking. I had mentally categorized Linda as a friend, forgetting the savvy business advice she had provided me over the years. Imagine the time I would have saved if I had already learned my *ideal network* lessons and listed her under "Business Mentor." You can bet that's where I have her listed now!

Here is another revelation I had while looking over my list of friends. I came up with a gentleman I couldn't put a label on, for some reason. It became clear that I was trying to make him fit into an existing category. My connection with the gentleman had often occurred when a situation was brewing for which he wanted help in establishing clarity. He always liked my advice and I liked feeling

needed, so I considered a new category for him. As it turned out, he had company in that category. I'm a nurturing sort. I had to admit that there are people who are in my life because they allow me to help them. I care about them and genuinely want to be supportive when they have challenging life situations arise. These friends satisfy this need in me. Therefore, my *ideal network* includes a "Need Me" category. Well, that's what it is. Why try to find prettier words?

The *ideal network* is really a way of "rethinking" in terms of how you view and use your connections. In my *ideal network*, I have some people who are "Endorsers" for me who are also "Spiritual Supporters." One of my "Mentors" is also a "Problem Solver." As you see the names all laid out, move them around until you are comfortable that you have done your best. Your goal is to file them like you use them.

In the end, you may find that your new "staff" directory" is a mix of business-related positions and personal support. Some of your categories will be practical, while others will be "soft" or serve an emotional need. This is what makes The Ideal Network System different from a general management tool; your new network is now an accurate reflection of you, correlating perfectly with all aspects of your life.

You are a combination of needs and goals...work and play...dreams and beliefs. Being able to see that big picture and make the best connections for every part of your life quickly is of tremendous benefit. It is why The Ideal Network System works so well for those who are creative and busy with many projects that fill their time. You need to see yourself for all that you are and all that you do in this world. You contribute...you are important...and support is not a luxury; it is a requirement.

Step 4

Complete this same procedure for the rest of your contacts, including any family members you'd like to add to your *ideal network*. Keep your Service Providers and Community Associates under your alphabetical listing, unless, of course, you determine that some of them should be categorized under a particular project. (See "My *Ideal Network* Categories" below.)

Occasionally, you will categorize someone by what they do, versus who they are or what personal role they serve. One example is Media, which is explained below. Having a few necessary categories, such as these, facilitates getting things accomplished. Go ahead and enter these people under their newly assigned categories, using whatever means of management you prefer.

I manage my *ideal network* in a Rolodex® organizer with blank tabs, because I like being able to flip to exactly what I want whenever I want (without having to worry about technological malfunctions). Unlike my alphabetical address book that gets toted to meetings, my *ideal network* is kept in a private location. Although I share frequently from my network, the positions that my "staff members" fill are created by me and particularly for me.

I do have a couple of categories for projects that I am working on that include the names of vendors. I also have practical categories that include Internet passwords and account information.

Currently, some of my categories are:

- Mentors
- Media
- Connectors
- Book Project
- Charities
- Entertainers
- Celebrities
- House Project
- Info-Exchangers
- Need Me
- Supporters
- Genius Pool
- Decision Makers
- Endorsers
- Problem Solvers
- Coaches
- Business Mentors
- Spiritual Supporters
- Web site
- Creative Entrepreneurs

<u>Step 5</u>

There are three categories that are must-haves for any network that you note in my list: <u>Connectors</u>, <u>Media</u>, and <u>Mentors</u>. A connector is someone who knows everybody and loves to network and make introductions. Media would be any member of the media with whom you have a relationship, or anyone who could help you with media relations or in securing publicity. Mentors (discussed further in Chapter 7) are golden because you look to them for inspiration. (If you lack enough names in these three categories, read Chapter 4 on filling your network vacancies).

When you come across a contact you think might be a good fit for your network but you're not sure where they belong, place them in "holding" (i.e., your alphabetical listing) for a while. When you have the opportunity to network, you'll no doubt find just the right category for them in your *ideal network*. There's no limit to how many categories you can have, although too many categories will defeat the purpose of making it easier for you to find good connections.

So, I'm curious—did you experience any revelations while you were reviewing your old network? Make notes, because this exercise can be very telling about how you view your connections.

Now that you are somewhat organized, you may have figured out that this isn't rocket science. Categorizing contacts by how they satisfy your needs is smart and practical. When you need a psychologist, you look under "Psychologists" in the phone book. It's obvious: categories make things easier. Your *ideal network* has customized categories to keep you from overlooking some not-so-obvious resources. Your *ideal network* isn't meant to be fill-out-a-form standardized. Your *ideal network* just needs to be perfect for you. It's *your* network, containing *your* customized categories. You are uncovering the truth about your current network—the good, the interesting, and the questionable. It's all so simple, but simple is almost always better.

Chapter 3

THE IDEAL NETWORK SYSTEM IN ACTION

Part 1: Your Role in Your *Ideal Network*

"America had developed world-class orchestras; we all know that—some of the finest on earth, each with its distinctive sound. But is that our true goal? Isn't it rather to have these same fine orchestras each capable of producing the distinctive sound not of itself, but of the composer being played?" –Leonard Bernstein, Legendary Composer and Conductor

Have you ever gone to the symphony and sat there listening as each musician warmed up his or her instrument? The odd tunings before the performance sound so chaotic, and yet, you walk away after the performance with a feeling of complete awe. A collection of world-class musicians are brought together to breathe life into a dream made of music. But, it's not their music. The music, the dream, belongs to the person who conceived it—the person who lost sleep, couldn't eat, and probably angered family members because he or she was obsessed by creating music. You are that person. You are the composer of your own joy. More than that, you are also the conductor.

Always remember that whatever it is you wish to achieve via your *ideal network*, you are the leader. Even with the added contributions (or interpretations) of others, what you create, in the end, should sound like you. I'm not saying that we should fear other

people's interactions with our projects. What I am saying is this: With all that we invest in our work, we should be keenly aware of our role and its significance in bringing our own ideas and projects to fruition. This comment should sound a little like Leadership 101, and if it does, that's good. There always has to be a leader, and in most cases, an end result will resemble its creator.

Case in point: A gal I know (we'll call her Sarah) created a partnership with a friend to help her with those pesky marketing chores associated with her talent-based business. At some point, the friend expanded her role within the partnership and began doing more of the creative work. Here comes the problem....

Sarah's identity with her own project dwindled as she allowed the partner more freedom. The partner actually began claiming legal credit for her contributions. The project had turned the corner; it was looking less like Sarah's and more like her partner's. As you can imagine, as with a great many friendships-turned-into-partnerships, this situation did not end happily. The partnership dissolved.

It doesn't matter if the person is a well-meaning friend or an associate from your network; my suggestion is to work out all of the details in advance with anyone you feel will be a significant collaborator on your project. For instance, when I take on a "partner" in a project, I create a sort of "job description" or listing of duties for each of us, including operational information like payments, billings, who will serve as primary contact, and how paperwork or other materials will be handled. Furthermore, I try to create an "easy out" in the case that the situation becomes undesirable for either of us. This written document outlines a separation of duties and helps to keep us on track and the partnership strong. So, when considering a collaborator or partner, I would advise to get their "job description" clearly in mind before any agreement. By handling business using this approach, you are not only taking care of yourself, but you are doing your collaborators a favor too, because they know what their parameters are. Be appreciative of their efforts, and always heap ample credit where it is due. Keep it all neat and clean, but make sure you are the leader.

The Ideal Network System is your best means of maintaining your identity with your work, whether you are running a consulting

business or are on your way to becoming an award-winning sales professional. You know what you really want to do, so plow through all your ideas and zero in on the one goal that is most important. Maybe you've put it off because of the effort involved, or the fear of a lengthy commitment. Perhaps you've tried to find shortcuts by creating a distracting, but related, goal. It's time now to give up the excuses. You have the "staff" to help you achieve the goal because you are organizing well, selecting well, building well, and managing well. Since organizing and selecting are so important, let's examine them first.

The curtain has gone up and there you are, mid-stage, with a microphone in your hand, ready to produce your own very special project. Before you stands a veritable sea of people who have arrived to audition for your "cattle call"—your network. You need the best crew for your production. Forget the obvious choices, the friends who have always come through for you and would be hurt if they were left out. Keep in mind that you want a finely tuned orchestra—the best musician for each seat—a cast that perfectly fits each role.

Are you unsure as to how many people it will take to get your production off the ground? That will become evident as you move forward and start casting. Be purposeful in your selections. Keep in mind that each person on the stage thinks they know how to contribute to your project better than you do. But, here's the rub— you guessed it—this is not *their* project. It's *your* project. Just take it easy and trust your instincts. Sometimes the gestation period for a project can be much longer than originally anticipated because it takes a while to work out the details. You are going to have to stay on top of the project long enough to see it through. That is your responsibility to yourself and your dreams.

Now let's get ready for those auditions…

Part 2: Utilizing Your *Ideal Network*

At this point, you need to first define what specifically needs to happen with the project, and then you can commence the search for who you need to help you produce. The "what" question comes first, because it defines the gap that exists between you and your

goal. The "who" question will direct you to particular people within your network categories who will link to your "what" question.

The five sample "what" questions below, and the "who" questions that can be asked in conjunction with each of the "what" questions, are provided to prompt you as to where to look in your *ideal network* to find the connections you need. Fill in the blanks with the exact goal or project you wish to create.

1. What is the biggest hurdle that I face in trying to _____?
 The accompanying "who" questions could be: Who are my problem-solvers?
 Who in my network is a strategic thinker?

2. What is the end result of _____?
 Who are my advisors?
 Who are my role models or people who have done what I wish to do?

3. What do I need to do to gain visibility for _____?
 Who are my media connections?
 Who in my network is successfully self-employed and has to do their own marketing?
 Who in my network is good at public relations?
 Who are my brainstormers?
 Who is a connector in my network and knows everybody?

4. What is the next step toward _____?
 Who in my network loves details and is an organizer?
 Who are my mentors?
 Who in my network is great at coaching and advising me?

5. What can I do to feel more motivated about _____?
 Who are my supporters?
 Who in my network stimulates my creativity?
 Who are my endorsers?
 Who are the success stories in my network?
 Who in my network needs my advice or help so that I can contribute and feel confident?

The "what" questions need to relate as specifically as possible to what is happening with you at the moment. Do you know what you want to do? Are you stuck? Are you heading in a surprising direction and in need of guidance? Are you presented with circumstances or options that confuse or upset you? Are you working on a major project and simply need some help in figuring out a plan? Are you mentally exhausted about something that you fear won't materialize?

Here's a scenario: Steve is a business consultant who has just started his business as a "sideline" while he still works at his full-time bank teller job. Although he has some practical concerns about how to transition this sideline business into something that will allow him to leave his full time job, his real issue is more about self-confidence. This is evident as he has become passive about potential new clients and loses others due to what appears to them as a lack of interest. Since this is currently what is happening with him, and because this situation could cost him his business, this is the issue around which we would frame a "what" question.

Do you see yourself in Steve, or is something else going on with you? Nail down exactly what is happening or not happening, personally or professionally, and frame that in a question. For most of us, the two areas are intertwined and greatly impact one another. Focus on whatever is most concerning you regarding the gap between you and your ultimate goal. Satisfying this concern is your first goal. Write down your "what" questions.

Steve's "what" question regarding his lack of self-confidence is "What can I do to develop more confidence in my abilities as a business consultant and a self-employed business owner?" Developing that confidence will eliminate the fears Steve has in becoming successful enough to leave his full time job. Now that we know the "what," it's time to address the "who."

Hopefully, it is obvious from the sample questions on the previous page that the more "who" questions you can ask, the more options for answers you'll get from your network. In the scenario with Steve, his "who" questions might include: 1. Who is great at advising me? 2. Who supports me unconditionally? 3. Who in my network has started a business as a sideline just as I have done? 4. Who in my network is fearless with challenges? 5. Who is good at

getting me motivated? Some of these may resonate with you. Write down as many "who" questions as you can think of that could prompt an answer to your "what" questions.

Once you've got your "who" questions, go to your *ideal network* and write down the names filed under the categories that relate to the "who" questions. In Steve's case, he might access the following categories to find the best contacts to help him address his self-confidence issue: Advisors, Coaches, Supporters, Risk Takers, Motivators, Self-Employers, Role Models, Endorsers, Problem Solvers, or Success Stories. You'll notice that many of these categories actually contain some form of a word from Steve's "who" questions. This process should be quick and convenient, providing you with plenty of options from which to draw expertise and support. It is a different way of getting needs met, but it isn't difficult. And, because it is simple, it can also be fun.

As a means of stimulating your creativity, I'm asking you to think of this whole process as an audition. The "what" questions would represent a scene from the play. The "who" questions equal the character breakdowns, the roles you need filled to perfectly cast that scene. Your *ideal network* is your talent book, and the names you come up with are your potential cast members.

The next step is to begin your production. Call, e-mail, and make appointments for lunch or coffee with your cast choices. You need to make contact right away. Timing is everything, because distraction is your enemy. With your "what" question in mind, ask for what you need from each person based on why you "cast" him or her. I'll use Steve's situation again as an example. As Steve makes contact with the person from his "Advisor" category, he would explain that he needs some advice on how to overcome these feelings that seem to be sabotaging his new business endeavor. He should ask if that person might know of any resources or other contacts that could also help.

When Steve calls his "Problem Solver" contact, he would outline the problem and ask specifically for what he needs from the contact—help in identifying a solution. That help may come in the form of information about a class he can take, the name of a good role model for him, or a success story that gives Steve a boost. Steve's clarity about his situation and his honesty with each of his

ideal network contacts will secure all kinds of help, but it will be up to Steve to follow up on whatever is provided to him.

Here's another scenario that may put things into perspective. My buddy Jeff called one day. It seemed that he really wanted to work in a career where he had no previous experience. He wasn't sure if this was even a viable consideration. The "what" for him was put forth in this question: "What can I do to pursue this new idea, and should I even try?" Jeff's lack of surety pointed him in the direction of someone he knew would give him support, advice, and honest feedback. I was his first "who." He needed to feel validated and clear before he could go ahead. The second "who" worked inside the industry of his new interest. This "who" provided him with knowledgeable answers to his questions and even an opportunity for him to gain some experience in this new area.

I am quite aware of how hard it is to ask for what you want or need to help you succeed. Sometimes, asking outright for information to explore a totally different career path feels like we are exposing too much of our private selves. I tend to be entrepreneurial, so I'm familiar with the amused smiles that often accompany the question, "So what are you doing these days?"

Once I overheard my husband talking on the phone with his father. As my husband tried to explain what "project du jour" I was managing, I could tell he was also trying to answer my father-in-law's somewhat skeptical questions about my previous professional episodes. My point is—why bother worrying about what others think? Creating something new is not a task for the weak or easily embarrassed. Ask "The Donald" what it is like creating success.

LEVEL 1, 2, and 3 CONTACTS

View the people in your network with whom you make contact to get answers to your "what" questions as your Level 1 step to success. Here's an important key as to how The Ideal Network System can pay off for you in an even bigger way. The premise is easy and you've probably heard about it before. It's a process I call connect-a-name: Always ask a contact for another contact. Whoever you have selected from your network to help you with information, opportunities, or guidance likely knows other people

who can be of help. If your network member is kind enough to make an introduction for you, then that truly is an *ideal* connection.

When your Level 1 connection gives you a contact, that brings you to Level 2. Level 3 is reached if you get that Level 2 connection to give you another contact. You continue that process of creating next levels either until a connection does not give you a contact, or you reach your goal.

There are a couple of great points about connect-a-name that you should know and practice. First, you can do this activity with several Level 1 contacts from your network simultaneously; and second, one Level 1 contact may end up giving you several Level 2 connections.

It is fun to see how fast this process can go. I actually enter these connections on my connect-a-name charts, and when I do, I often try to project the Level 2 people or types of people with whom I'd like to connect. For instance, if I'm connecting with a Level 1 contact for the purpose of finding a professional organization that is looking for lunch speakers, then the Level 2 contact I'd hope for would be an organization's secretary or scheduler.

It helps to keep my focus, and the chart can be changed if I am presented with a different Level 2 connection than what I had expected. I do this charting for practically every client task and personal goal I have. For clients, I keep the charts in a file and can produce them at meetings to show progress on an assignment. The charting also keeps things streamlined and offers a sense of direction if I feel somewhat clueless. (I'll give you some samples of charting to check out at the end of this chapter.)

Back to Jeff's story…. When he called me initially to talk about a potential new career path, I became part of his connect-a-name system. I provided him with a connection to someone who had worked in the area where he wanted to work, and I pre-introduced him in order to make the connection go smoothly. What Jeff primarily needed from me when he called was support and feedback, but he knew that I was also a "connector" because I've connected him before.

There may occasionally be Level 1 folks in your network who will offer up names without your asking. But the lesson here is:

Even if your current "what" questions call for only support or advice, never fail to ask if there is anyone else who may be a good connection for you.

I'd be remiss if I didn't have you put The Ideal Network System to the test now. You have organized and prepared your *ideal network*, and you understand the basics of utilizing your network in a connect-a-name fashion to get quicker, easier results. So, let's see what you can do. Why not make a phenomenal connection with someone who inspires you? You may have someone like that in your network already, but allow this connection to be someone new; a person you think is just outside your reach. I'm not talking about a megastar; I'm talking about someone really successful who possesses the personal qualities, the lifestyle, or maybe the kind of spirit that you love.

If a name doesn't come to mind, then at least develop a good idea of what type of person you are seeking. Perhaps it is someone who enjoys life and learning, a woman with tremendous style and presence, a leader who seems to be involved in interesting projects, or an entrepreneur who manages multiple diverse businesses. Consider what it is about the person that causes that sense of awe in you. The more clarity you have, the more likely you are to triumph over this challenge.

Since we operate with the "what" and "who" questions to activate your network, let's get those questions together now. Your "what" question is: "What type of person inspires me?" As you are connect-a-name charting this, enter your answer in a circle at the top of a sheet of paper.

Three things are generally known about highly inspiring individuals. First, their work or talent has to have an outlet, such as CDs, seminars, books, businesses… whatever. This is the means by which they make themselves known, so we'll call it their "vehicle."

Second, people who inspire usually have a management mechanism in place. This could be anything from a corporate structure to a secretary, publicist, partner, or scheduler to help them manage their vehicles for optimum success.

Third, this person has you, in that they have captured your imagination and a part of your spirit, and perhaps is living your dream. What is it that truly draws you to this individual?

Sometimes it is not so much what they've accomplished as what magnetic personality trait or quality they possess.

Here are some "who" questions to identify the right contacts in your network to help you make this connection:

- Who in my network is a connector and could have ties to the specific geographic area, industry, or network for the person I chose?

- Who in my network is a brainstormer and may have ideas about resources that would help me find a connection?

- Who in my network is a leader and can tell me how they made significant connections?

- Who in my network is a supporter and likes helping me to succeed with my goals?

- Who in my network is in a similar category to the person I chose?

- Who are my professional media contacts, and have any of them ever interviewed the person I chose, or could they have a connection in addition to the inspiring person I chose for me to consider?

Choose the questions that provide a link for you, and come up with some of your own. Then select members of your network who will fit the answers to those "who" questions. Enter the name, or names, at the bottom of your chart in individual circles. These are your Level 1 connections.

If you still haven't decided on an actual person for your "inspiring-person connection," just be clear on the *type* of person you are looking for. That will be what you enter in the circle at the top of the chart until an actual name surfaces.

Now, make the connections to your Level 1 people. You are asking for connect-a-name contacts to lead you to the individual you are seeking. However, you may get unexpected bits of advice or resources that prove useful as well. For example, sometimes a referral to a particular Web site can get you to the point of connection; you can certainly begin your quest with an Internet research to help you clarify what you are after. If you've got your

"mojo" on, it could be that a wonderful, brand-new Level 1 connection will reveal himself or herself during your search.

However, don't discount your own *ideal network* as being able to produce what you want. Using personal connections from your network for starters, whenever possible, is preferred for a multitude of reasons. Besides enhancing your chances for an introduction to a new contact, you create stronger ties with the current members of your network. Also, every interaction with your network "staff" brings you more information about who they are and who is in *their* network. If you select the right people from your network to help you, you'll receive assistance that will get you to your goal faster.

A note based on experience: When you know the exact name to use for a Level 1 connection, by all means use the direct route. But don't put all of your eggs in that one basket. While you are in the process of connecting with that person, come up with other Level 1 connections from your *ideal network*—they are your back-up, so to speak. For the purposes of this challenge, you can inform these connections that:

a) You wish to strengthen your network with people who inspire you

b) You are making contact to express your appreciation or to ask for perspectives or advice, or

c) You are taking up a challenge that was suggested in this great book you just bought about changing your address book and changing your life….

If any of your Level 1 connections take you to Level 2, draw a connecting line from that person's circle on your chart to a new circle directly above and enter the new name and contact information. I know that seems elementary, but it does keep you organized and when the goal is accomplished, you'll want to go back to those Level 1 people and thank them. When you get new connect-a-names, you will have some super people to add to your *ideal network*. Your "staff" has just expanded!

The really amazing part about all of this is that, as soon as you decide exactly the person or type of person you want to meet, the

gears of the universe start moving. Don't be at all surprised if he or she shows up right in front of you.

One day, a few years ago, I decided to try to track down a particular professional golfer and television broadcaster. At this time I was putting together a leadership program for professional athletes, and I needed some advice. I heard that he had a second home in my area, and I thought that perhaps I could set up a meeting when he was in town.

Never having laid eyes on the gentleman, I looked up some biographical information and his photo on the Internet. He was wearing a golf shirt bearing the logo of a local marina. I mentally filed that tidbit of information about the marina away as a potential path to search. But I started by reviewing my own network, where I made a Level 1 contact who would have been happy to help me make the actual connection. The problem was that the professional golfer was traveling, and no one seemed to know how to find him.

My Level 1 contact did, however, give me a Level 2 contact, a family member of the professional golfer. I called and was advised to wait for a locally scheduled event where I could possibly meet the man. Disappointed, I decided to resume with a fresh search the next day.

That night, my husband and I were sipping wine at the bar of a local bistro when a man appeared on my husband's right, waiting to pick up his "take-out" dinner. I couldn't help but notice his shirt— it had the same logo that I had seen earlier in the Internet photo. A waitress then said to him, "Hello, Curtis." Unbelievable. There stood Curtis Strange—championship golfer, network broadcaster, and Captain of the 2002 Ryder Cup Team—delivered to me personally, as if I had placed a special order. You might think this was a fluke, but these "coincidences" have happened to me before, so I stay alert for "coincidences."

Since I seem to be fairly good at making connections, I'm going to take up the same challenge I've issued to you. As of this minute, I am clueless as to whom I'll choose to attempt connecting with, but I'll let you know my choice and how I managed that connection in the next chapter. For now, you've got some *ideal* networking to do...and so do I.

Connect-A-Name Examples

What makes the connect-a-name format different from most planning charts is that it focuses on people connections versus a to-do list of actions. Making the right connections often reveals the "how" (or action steps), thereby saving a lot of time and energy.

For some projects, only one or two Level 1 connections are listed, as I wait to see what those connections give me for Level 2. On other occasions, I completely mapped out what connections I expected, perhaps a general title or description, to serve as a direction.

The charts below reflect the path of completed projects in which I utilized a combination of *ideal network* connections and general network contacts to achieve goals. I excluded individual names of some contacts, but you'll get the idea.

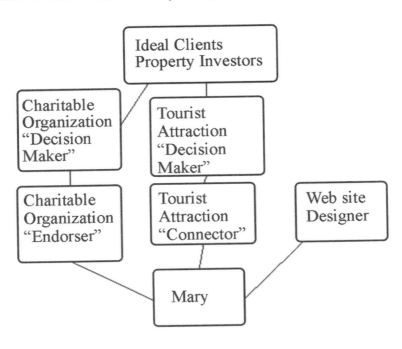

Example 1
Goal: Ideal Clients: Property Investors

The Selling Team is a top-selling real estate firm in eastern North Carolina. At one point, they were experiencing growing success with investment property and decided to shift their primary marketing focus to that part of their business. One of the partners made a Level 1 contact with someone in her network—me. Eventually I was hired to help The Selling Team with other connections.

After exploring some particular traits of their target market, we launched a focused effort to gain visibility with their newly identified *ideal* client type (property investors). I mapped out my connect-a-name chart, starting with a connection from my network (a Web site designer) to begin reworking their Internet presence with a more decided push toward investors. The Web site designer was Level 2. Once this step was accomplished, I began an *ideal network* category for my clients, The Selling Team. Every contact from my overall *ideal network*, and any new ones I acquired relating to this project, were filed in my Rolodex® organizer behind this category.

Next, I pursued some opportunities for visibility with a newly expanding tourist attraction in the area. Particular exhibits at this tourist attraction provided a direct tie to the environment of The Selling Team's *ideal* client type. I contacted a woman who worked at the tourist attraction whom I had casually filed in my general network. She now has a "Connector" title in my *ideal network*. She was a Level 2, and she kindly paved the way to a Level 3 contact who was the decision maker. A perfect sponsorship deal was negotiated. Along with the sponsorship came two invitations for my clients. One was a sponsorship social and the other was a large grand opening event, both of which would be attended by their *ideal* clients. All that was needed now was some great networking.

We further decided to seek specific publicity opportunities that would gain favor in the eyes of area property investors. This was a fairly easy challenge since so many of the investors served as board members for many of the area's charitable organizations. We targeted a group that had ties to someone who fit the *ideal* client profile.

Coincidentally, the connection for that organization turned out to be one of my *ideal network* "Endorsers," who was one of my Monday networking connections, and who had shared via e-mail that she had taken on a new job. Guess where?

This is a perfect example of one of those benefits you get when you make regular contact with key people in your *ideal network*. Her Level 3 connection was a decision maker within the target organization who called me and gave us the green light needed to follow through with the plan for visibility. Voila!

To recap: The real estate agents made one Level 1 connection. I made three Level 2 connections, two of whom made Level 3 connections on my behalf. All that was left was to follow through. Mission accomplished!

Side note: Although this work I did was for a client, one of my Level 3 connections added my name to an invitation list for a prestigious event. I added his name to my *ideal network*, and I'm thinking I've also made it into his network.

Furthermore, my Level 2 connection with the new job got a promotion and cemented her value at that company by providing a great sponsorship hook-up for their Number One charity. My Level 3 decision maker at that same company is now in my *ideal network* as a Decision Maker and Problem Solver. I discovered that she is an incredible resource for event planning. Working with her was not only a valuable public relations endeavor for my clients, but also gave me an opportunity to help a worthwhile charity in the community.

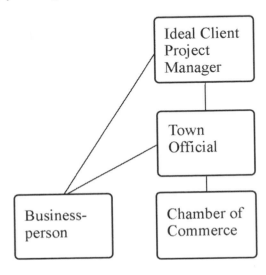

Example 2
Goal: Ideal Client: Project Manager

Wishing to expand my client pool to include community project managers, I used a Level 1 contact from my *ideal network* (a staffer at the local Chamber of Commerce) to gain some information about the best potential clients. Without hesitation, she gave me a couple of names, and emphasized one who was working on an area project of major historical significance. She also mentioned a Level 2 contact that would be a direct link to that *ideal* project manager. Enthralled, I set my goal. Before I could make the Level 2 connection to try to create a path to the new *ideal* client, something happened—an unforeseen circumstance fell right into my path.

I was made aware of what appeared to me to be a touchy public relations situation concerning the project. This uncomfortable situation involved a businessperson I knew, and it seemed to be an opportunity where I could be of assistance. I also realized that this event had provided the perfect vehicle for me to progress toward connecting to the *ideal* client.

The next step was to make the Level 2 connection that had previously been suggested by my Level 1 contact. The Level 2 connection was a town official. I made the call, and he not only supported my offer to help, but he also served as a reference when I established initial contact with the *ideal* client.

Another Level 2 contact was the businessperson mentioned earlier. A conversation with her was necessary in order to clear the way for any public relations work I might be able to conduct. Her particular role created links to my other Level 2 connection as well as to the *ideal* client. By week's end, the connection with the *ideal* client was complete and my goal was reached. The project manager became one of my best clients. The "touchy" public relations situation dissolved and the businessperson negotiated a very profitable business arrangement.

Wherever there is a gap between where a person is and where he or she wishes to be, connection is the answer!

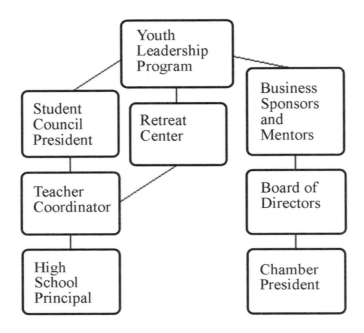

Example 3
Goal: Youth Leadership Program

Inspired by my experience in an adult leadership program one year, I was eager to produce a youth leadership version. Since there were only a couple of models for this type of program in the state, I did what homework I could to forward my idea and began making connections.

Two Level 1 connections were necessary. First, I determined that the program should reside at the local high school, so I called the principal. He connected me to a teacher who would end up being a coordinator for the program. Since I was a Chamber of Commerce Executive Director at the time, next, I approached the President of my Board of Directors with the concept. He then presented it to the full Board of Directors.

As you can see by the chart, this activity produced a Level 3 set of connections to make operational plans for the program. Although it took months to organize, the program became a reality and was a hit with student participants. A visit during the pilot year in 1995 by

North Carolina Governor Jim Hunt resulted in his proclaiming the program as a model for the state. Shortly after the program began, I solicited the support of a businessman in a neighboring county to start a similar program there. Both programs have since been in operation for more than ten years, and the second program draws participants countywide.

When I was just beginning to think about the idea, I had little more than tremendous motivation, and depended heavily on my Level 1 connections to provide guidance. Each connection in the chain moved me toward the next step. In an *ideal network*, that's precisely how it should work!

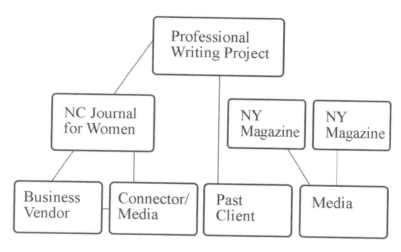

Example 4
Goal: Professional Writing Project

With the goal of landing a professional writing project or two, I e-mailed four contacts from my *ideal network*: a Connector and an Info-Exchanger who are also Media Contacts; a fairly new media connection; and a past client for whom I had done some voiceover work, thinking he might have other talent needs.

All Level 1 connections produced leads or Level 2 connections. The past client hired me for a writing project almost immediately. Although it is not shown on this chart due to lack of space, the Info-Exchanger/Media Contact told me about an opportunity for editing

a new publication in my area. It didn't prove to be an exact fit for what I wanted, but I was able to pass along that information to someone else who was interested. However, the new Media Contact gave me the names of two up-and-coming publications out of New York, and my Connector/Media Contact introduced me to the publisher of an online magazine that perfectly matched my goal.

With my Level 1 contact's encouragement, I called a Business Mentor from my network to secure an interview for an article. I wrote the article, which was published in the very next issue of *The North Carolina Journal for Women*, complete with a photo of my interviewee and me.

It probably took me less than an hour to peruse my *ideal network*, choose my contacts, and e-mail them with my request for leads. That minimum effort garnered me writing work that resulted in a couple thousand dollars, visibility within a target market for my own business, additional credentials, and an opportunity to spotlight one of my favorite people.

Example 5
Goal: Job Leads for 15 Clients

**Because of the number of clients involved, I am not using charts for this example.

When an area business owner made plans to cease operations, I was hired to work with the employees to help them transition into new jobs as quickly and smoothly as possible after the closing date. Fifteen employees asked for my assistance in preparing their resumes and securing leads for employment opportunities. Other than the challenge of helping that many people with a job search simultaneously, there was also the issue of trying to find employers who would be willing to promise positions more than a month in advance. In addition, some employees wanted to change careers.

I turned to my *ideal network* to begin making connections and used Connect-a-Name charts for each employee-"client." The process began almost three months prior to the cease-operations

date. Two months later, every client had two or more Level 1 connections for possible job opportunities. Some of those Level 1 connections presented Level 2 contacts. Connections were presented to each client on a Connect-a-Name chart so that he or she could follow up personally.

With about five weeks remaining until the business closed, I received a phone call from the person who hired me on this project. He thanked me for my assistance and told me it was his understanding that everyone who was interested in employment had secured a job.

Most of the Level 1 connections I made came from my *ideal network* categories of Decision Makers, Endorsers, Connectors, and Info-Exchangers. In total, more than seventy Level 1 connections were made. In the process, I helped two people who weren't even on my client list secure employment, and I added several new members to my *ideal network.*

As a final example, let's get you started on your own Connect-a-Name chart, involving a topic that may be of interest to you: Clients.

Here's your "what" question: What does your *ideal* client look like? Don't say that you'll take anyone, because "anyone" is exactly who will show up. You'll find yourself with clients that can't pay you on time, or at all. They may have addictions or behaviors that will thwart your ability to work with them, or will just be so difficult that you'll wish they had never found you. So get clear on the type of client you want, and then do yourself a favor: make that client "*ideal*" by using these steps:

- Enter your *ideal* client type as your goal (your "what") in the top box on the chart provided on Page 39, or make your own chart. You can also visit www.theidealnetworksystem.com and download a blank chart under "workshop forms."

- List the occupations, environments, networks, and hobbies most often associated with your *ideal* client type.

- Write down the "who" questions that relate to items you've placed on your list. These questions will direct you to the categories in your *ideal network* where you can locate your first connections. Perhaps you'll be looking for someone

involved in a professional organization whose membership includes your *ideal* client type. Maybe there is a business owner in your *ideal network* who has a direct link to your *ideal* client type. Jot down your *ideal network* categories next to each question.

- Go to your *ideal network* and search those categories for contacts that might be likely sources for good information and more connections. Pick two or three Level 1 contacts and list them in the bottom boxes of your chart.

- Make a call or send an e-mail to your Level 1 contacts. You are networking, which means you are exchanging information. If your goal is to secure a new client that is a community leader, then your e-mail could read something like: "Hey, Gayle…How are you doing? You've always got something interesting going on, so what's your latest project? Currently, I'm looking for an opportunity to work with someone who is active on a major community project. Do you have ideas or contacts that could lead me toward such an opportunity? And, if there's anything I can do to be of help to you, just ask." Here's what's going on in those few lines:

A) You ask a question right off the bat to indicate personal interest. You issue a compliment and ask about something important to them—their work. Since you've selected this person as a potential link to your goal or ideal client, whatever projects they are working on could be of interest to or provide opportunity for you.

B) You tell them exactly what you are working on and what you need.

C) You ask them for a Level 2 connection and introductions where appropriate.

D) You offer to be assistance to your contact.

- After you've made contact, enter any Level 2 connections given to you in the boxes that extend upward from your Level 1 connections. Draw lines from box to box to show the path of each connection.

- Enter any Level 3 connections you receive in the next set of boxes extending upward from Level 2. Draw the connector lines.

- Yes, you could actually end up with Level 4, but I rarely get that far. *Ideal* means quicker and easier, and although I adore stocking names, I really just want to get things done. But, if you hit Level 4, keep adding, until you connect to your goal box.

- Remember, save all names and contact information to add to your *ideal network* later.

- Be sure to thank all contacts and offer to be of similar help whenever needed.

- If you set up an action to take (such as telling a contact that you will call someone that they referred to you) be sure to do it, because the contacts that make referrals may follow up with you. They'll want to know if they succeeded in helping you meet your need. You will want to affirm with gratitude.

Fill-in-the-blank chart on next page

YOUR CONNECT-A-NAME CHART

Ideal Client

You can do this in under an hour. If you communicate to your contacts using e-mail, the rest of the day you'll be receiving e-mails offering information, advice, and connections without spending a half hour on the phone. It is actually possible that if you start the process at the beginning of the day, by close of business, you could have your goal within grasp. So, what are you waiting for?

Chapter 4

FILLING YOUR NETWORK (or STAFF) VACANCIES

One of my favorite books is *Building Your Field of Dreams*, written by Mary Manin Morrissey. The book chronicles Mary's amazing journey to achieving her own dream: a thriving worldwide ministry and the development of a church called The Living Enrichment Center. Attainment of the dream attracted some extraordinary opportunities for Mary, like an audience with the Dalai Lama and a one-hour PBS special based on her book, not to mention a highly successful career as a professional speaker. Not bad for a girl who was forced into marriage at sixteen because of pregnancy, battled a life-threatening kidney disease, and struggled financially for years (at times with mere pennies in her wallet).

In the summer of 2004, however, the dream was tested, and so was Mary—in a ferociously public way. The church that began in her living room and grew into a multimillion-dollar operation filed for bankruptcy. Amid IRS investigations and legal actions, Mary resigned her position as Lead Pastor. Published news reports included information that Mary's home would be repossessed and that she would declare personal bankruptcy. As if that weren't enough, her husband, who had recently been diagnosed with bipolar disorder, was charged with mishandling funds associated with the business. Legally prevented from publicly discussing the situation, Mary had to keep quiet while enduring the inevitable media battering. Unimaginable!

What would keep any of us who find ourselves in that circumstance from saying, "Just bury me and be done with it?" What would you hang onto in order to keep sane? According to Mary, it was faith, and it was the faith of people in her network that provided the first stepping stones to her possible recovery. Fellow speakers, authors, and seminar leaders showed up to help raise funds for her legal expenses and to keep the ministry alive. The best part was, everyone benefited.

I thought hers was an incredible story when she told it to me over the phone. Mary's book had inspired me several years ago. I quoted from it at events where I speak, and I told clients and friends about her work.

In fact, minutes after I finished writing in Chapter 3 that I would also take the challenge of connecting with someone bigger than life, I determined that Mary would be my choice. I didn't know that she was at that time overcoming major personal and professional challenges. When I found out about her current situation through Internet research, it occurred to me that the difficulties in making the connection with her could be overwhelming. Maybe I was naïve, but I persevered, figuring that colossal interruptions seem to be an odd, but natural, part of the life of a person who lives in the spotlight. I know she's dealt with craziness before and has only emerged stronger, so I assumed that she was still "doing her thing" out there somewhere, and that I would find her.

Within a matter of hours, on the same day I finished writing Chapter 3, and with only one Level 1 contact, I found Mary Manin Morrissey. I'd love to be able to explain how I used several connections to find her, but what actually happened was that the one connection I made (that Level 1 contact) was the type of person I knew I needed. That person was an organization contact who provided me with an introduction to the author I was seeking.

Mary and I spoke twice the following week. Her words over the phone were the same as I have read in her books—straightforward and inspiring. She seemed to be working hard to turn this critical event in her life into a success story for all concerned, and the hard work was paying off, as her plate filled to overflowing with engagements. What appeared to be a long and painful course for

everyone involved is looking more like a "divine transition"—in essence, an opportunity to put spiritual principles into practice and explore new paths. Upon reflection, what I took away from my moments of communication with Mary is this: There is always heart behind every effort to inspire. Mary's heart allowed her to deliver words of inspiration at a time when it was needed. Those words, and the heart behind them, won't be forgotten.

So, the reason for having you connect with someone who excites or inspires you is three-fold. First, the experience of making this kind of *ideal* connection is mind-blowing. I could hardly speak two words that made sense for the first few minutes Mary and I were on the phone. I was simply stunned at having found her and so quickly, much less that she would take the time to talk with me. The whole thing kept me on a high for days. Everyone deserves that feeling, often. If you haven't done it yet, get busy and complete that challenge from Chapter 3—make that connection.

Second, if you felt inspired by my story of connecting with Mary, then you're participating in a kind of trickle-down effect. It is as if Mary gave me "license to inspire" when she allowed me to share her story with you. Any time you feel completely absorbed by someone, the experience of that connection compels you to talk about it with others, creating a magnetic energy. What began as your experience has now become a gift that you've passed along.

The third reason for making the inspiring connection is that your *ideal network* gets an instant upgrade when you add someone who inspires you. Call it a phenomenon, an elevation of a spiritual nature, or whatever you want, but it does happen. My own explanation relates to the level of confidence you acquire through this type of connection. You suddenly feel empowered, and the fear of connecting with someone outside your usual circle no longer exists. This new posture attracts more of the same type of connections. The bennies are too good to miss. Filling vacancies in your network by starting out with an inspiring connection is a great way to get motivated. If you have accomplished this first assignment, then filling other vacancies will be a "walk in the park."

Relationships with people of different occupations, beliefs, and personalities will enrich one's life. Building diversity into a

network will produce a menu of personal and professional opportunities as opposed to "more of the same."

There's one particular word that becomes significant when filling your network vacancies: diversify. I have a mantra for you to use for the rest of this chapter: Diversify and become a powerhouse. Actually, I think the best part of that mantra would be the word "powerhouse." Sounds big and important, doesn't it? It is! Making sure that you have a variety of great people in your network will be the difference between your being mediocre or fabulous. As you expand your *ideal network* in this way, here are a few simple rules to follow:

- You are already making important connections for yourself; begin also to make them for others. I've touched on this before, but it needs repeating. You cannot ask for and receive continuously without giving back. Be alert for people who should be connected with others. I'm not telling you to play matchmaker, but if someone you know is looking for a job, consider who you know that might be a good contact. If you know someone who needs a luncheon speaker or someone who shares another friend's interests, assist in making that connection. Practice this continuously as a general rule.

While making a networking call to the scheduler for an international exchange program, I was informed that a group of foreign leaders, among them a member of royalty, would be visiting the area. Envisioning an extraordinary opportunity, I called a local school and tracked down a teacher who coordinated a youth group interested in minority issues. I then connected the teacher with the scheduler, and over lunch one beautiful day, a memory was made for both students and foreign leaders. That gesture not only proved valuable for others, but it also strengthened my own connections, which later resulted in my booking a group meeting with a U.S. ambassador.

- Make connections "outside" of your dream or immediate goal. The result of what you want to do is really to achieve a lifestyle that you desire. True success always begins on the inside; in fact, it is the journey that is the most important

part of the quest. You've heard it before—who you are is more important than what you do. So, take time to look inside and play. You have an opportunity to explore and make connections in other areas that interest and excite you.

- When you start looking at a variety of people for your network, make sure they are not mirror images of you. New contacts should possess some qualities, interests, and histories that are different from yours.

Are you wondering where you might find these incredible new people for your network? Well, of course, you can access your *ideal network* and "connect-a-name" your way to specific new types of people, and if you want to really open the door, listen up: There are as many ways to network as there are people with whom to network. The *ideal* methods are the ones that suit your personality best. I'll give you twelve *ideal* networking tips right here. As you review them, consider the most effective way that you interact with people. Do you like in-person communication, or would you rather call or write a person? What vehicles for meeting people make you feel the most relaxed? When you are relaxed, your natural abilities move forward and you present yourself with sincerity. This is not to say that stepping out of your comfort zone isn't called for when upscaling your networking efforts, but make sure whatever opportunity you choose is of real interest to you.

1. GATHER ENDORSEMENTS

This is what I call "functional networking" because you have a useful reason for connecting with people. Written endorsements are incredible. I've used them with resumes, grant applications, on a Web site, in my marketing materials, in letters of request, with project proposals, and anywhere else that I want credibility. Endorsements differ from testimonials in that the former has more to do with you as a person (qualities/character) and the latter is more specific to things you have done for other people (your skills). Conducting an endorsement search causes you to connect with people you like and whom you know

appreciate you. Make a list of people, and then ask each one for a paragraph summarizing your character strengths. Be specific about what you want in the endorsement. This activity reminds people of how wonderful you are and, specifically, how good you are at what you do. Even though these people know you, it's a terrific mind-jog that could inspire your endorsers to make spontaneous connections for you. Always express thanks and, where appropriate, offer to return the favor. Be sure to make an "Endorsers" category in your *ideal network*.

2. BECOME A CONNECTOR OF PEOPLE

We've talked about this a bit, but in a "giving back" context. This tip relates to the more practical form. Every established salesperson knows the term center-of-influence. A center-of-influence is (like our *ideal network* connector) basically someone who knows everyone. There are other qualities you'll find in this type of person, but generally, if you need the best handyman, the most experienced attorney, reliable caterer, or cleaning service, this is the person who can give you the name. As a "connector," you will become a source of referrals. Your network will be so broad and so deep with valuable resources that everyone will be calling you for help. To get the ball rolling, you must begin gathering resources. Do a little research and make some contacts with service providers you know or have heard about. As you start the process, you'll realize that everyone is looking for something or someone (a job, a bookkeeper, a good restaurant). You will provide that referral, receiving much appreciation, which builds your credibility. This can lead to endless interesting opportunities. Since these new connections will be service-oriented, they should be included with your "community associates" in your regular alphabetical listing.

3. START A CLUB OR ORGANIZATION

Probably the most unique segment of my own network came about because of an organization I developed. Founding a

nonprofit organization expanded my network by hundreds. The process gave me a reason to meet community leaders, philanthropists, and sports professionals at every level and in a variety of sports. More than that, I made some spectacular friends who are still there for me today. These are all people whom I would not have met otherwise. I'm not directing you to go so far as to create a foundation (unless it is what you want), but you can imagine that even starting a small book club, writers group, or jazz appreciation gathering could expand your network in interesting ways. You'll meet people who enjoy what you enjoy or who are devoted to your cause— and they'll bring in others. Forming an organization not only builds your network, but you are providing an opportunity to help other people grow their networks. If you're not an activist by nature or don't care for fundraising, then start with what you love—a hobby or a talent you'd like to nurture. Then, put an ad in the paper, contact some friends, have them contact a few more, and get on the local talk shows. Almost from the moment you conceive the idea, your club is born.

4. CREATE A PUBLICITY VEHICLE FOR OTHER PEOPLE

Whenever you have even the smallest publicity vehicle, there will be people clamoring for your attention. How can you create one? You can host a local cable television show or radio talk show, write a local column that spotlights certain people, or send out a newsletter that features different businesses. You can create a talent, fashion, or art show; put people's links on your Web site, ask them to speak at your club, or write an article, or give a lecture, and reference them as an expert. Ask them to be a special guest at a class you teach, or bring together a group of talented people and produce your own project to spotlight everyone. Trust me, whatever it is, the people will find you.

5. ATTACH YOURSELF TO THE MOST VISIBLE ENTITY IN YOUR AREA

What is the organization, company, or group in your area that is constantly in the media? It's fine if the organization is controversial, as long as it is highly respected. Is it the Tourism Board or the Arts Council? Maybe you have an attraction in your area that the whole town centers around. Does this entity have a board of directors or a supporting organization? Is there a company that supports everything from high school football to environmental research? Whatever it is, there should be a way for you to affiliate. Volunteer your talents on a committee, join the group, and attend the meetings. There must be something about it that interests you—find it. If this group is getting attention, it no doubt has a vast and impressive network. Affiliation will give you instant access to that network. You probably already know someone who can get you connected. Go for it.

6. GET ON BOARD WITH A NEW IDEA

While sitting in a meeting, reading the newspaper, or driving with the radio on, you hear about new projects. The seeds of what will become the First Annual Charity Ball or the Jack Davis Memorial Park are being planted. Perhaps a kid's soccer league is forming, or maybe a huge entertainment center is being discussed for the area. If it is something that has not been done before, listen carefully. Along with the headaches of creation comes the excitement and genius of pulling off a "first." The people behind this are nothing less than "founding fathers," and you cannot afford not to know them. They will become some of the most valuable members of your network. If the new idea sparks interest in you, seek it out and get on board. If it is perceived that you, too, are one of these visionaries, you will attract other visionaries. Opportunities will find you. Just know yourself and what criteria must be in place for you to consider anything new.

7. CHANGE YOUR ROUTINE

If you shop at the same grocery store, always do the same volunteer work, or have lunch at the same diner, consider introducing a little variety into your life. The same routine, though comforting, doesn't allow for meeting new people. If changing grocery stores gives you the "heebie jeebies"—then change the day you shop. If you go to church on Sundays, try a mid-week service once in a while. Think about the routine activities in your life where you are seeing the same faces all of the time. One simple change could bring a new friend into your life, or reconnect you with someone you haven't seen in years. Oddly, making a change is probably the most difficult because people tend to cling to the familiar. But remarkable things happen when you engage a fresh flow of energy. Give it a try.

8. TAKE A TELECLASS

A teleclass is the least expensive, most immediate way I know to meet people literally from all over the world and learn something at the same time. A teleclass is like a virtual classroom conducted over a "bridge" telephone line. When you sign up, you are sent instructions and a telephone number to call at a certain time. I've taken complete courses through the teleclass format, and I have facilitated some myself. Some "teleclass-mates" have become good friends as well as business collaborators. Teleclass subjects range from technical and academic information to marketing techniques and even spiritual enhancement. The cost can be free, or you might find a series that ranges into hundreds of dollars. Many teleclass offerings can be found on the Internet through a quick search with the key word "teleclass." If expanding your network nationally or internationally sounds like fun, you'll love this.

9. GET "SOCIAL" FOR A MONTH

For most people it is hard to think about networking as a way of life. We generally think about networking when we are

fundraising or selling something. Try this: for one month, become a "social butterfly." Your aim is to respond "yes" to every invitation that you receive during that month. Let friends know that you are doing this, and tell them you are available to accompany them to their events (anything where five or more people are gathered). Activities could include ballgames, receptions, festivals, seminars, dinners, concerts, and club meetings. You can even create your own event(s) during this month, but be sure to ask new people to come. This might seem a little intense, but you can hang with it for a month. Just think how gloriously full your network will be as a result. And don't be surprised if you find yourself invited to even more social events in the following months.

10. HANG OUT IN ANOTHER TOWN

There's this sweet little waterside town not a twenty-minute drive from where I live, but it couldn't be more different than my daily environment. The bed and breakfasts there replace the usual chain hotels, and quaint shops with bicycles out front practically beg you to explore. The people are an odd blend of artistic nomads and sea-loving business types. My husband and I found a second home there, making a cozy little wine bar our Friday night hangout. Casual acquaintances quickly became friends. What started out as a weekend "getaway" one day became something much more. It can be the same for you. If there is an atmosphere that draws you within an hour's drive, why not investigate? Observe for a while and see where you fit. The right "hangout" is there with plenty of new, warm, friendly folks waiting to know you.

11. BE UNIQUE IN YOUR COMMUNICATION

A handwritten letter always makes the receiver feel special. But there are other ways to achieve the same effect. In my community, there is a gentleman who regularly sends out area photos by e-mail to us that can be forwarded to our family and friends. My favorites are the beautiful sunsets or local events

shots. A friend of mine sent out homemade valentines one year to her network. The one I received was so ornate that I kept it forever as a bookmark. Her valentine inspired me to design my own note cards, creating them with beads, seashells, ribbon, tissue paper and even sequins. So well received have been these special cards, I was actually commissioned by a client to make them for her potential clients. Being unique in your communication is as much about using your imagination as it is about having talent. Why simply adhere to the "ordinary" when it comes to reaching out to people? Your *ideal network* deserves your creativity and personal touch. Find your own method and practice it by reconnecting with people you've just met. They will have a hard time forgetting you.

12. SIGN UP FOR HOSPITALITY

Networking takes on a whole different perspective when you become a "host." Being a "host" means someone else is a "guest." When you become a host, you send a message that you are extending the privilege of your presence, your home, your food, and your own network to others. Although it might not seem so personal, hosting is a rather intimate endeavor. You are exposing parts of yourself in this role that might not ever be visible to others. You will also get to know your guest(s) in a generally social environment (often on your turf). Guests who have been taken care of tend to be looking for ways to reciprocate. Opportunities, advice, and connections are shared. Other than planning your own parties and events, look for organizations that need volunteers to host or provide hospitality for people. The Council for International Visitors, through the U.S. Department of State, has member agencies throughout the United States. These CIVs are excellent sources for hosting. They provide professional appointments and hospitality for visiting dignitaries who participate in the U.S. Department of State's Cultural Exchange-Leadership Program. I worked at a CIV at one time and had some extraordinary dinner guests— female legislators from Johannesburg, a tribal chief from Botswana, judges from Nepal, a politician from England, and

the editor for a major financial journal from India. Now, this is called diversifying your network! If I've gotten your attention, check out the National Council for International Visitors Web site at www.nciv.org to see if one of their 95 or so member agencies is close by. Other exchange groups, military support groups, dinner clubs, theater organizations, or church groups are some good ideas to consider when looking for hosting opportunities. The main thing to remember is, do it from the heart—do it with class and make it work for you.

These are just a few ideas to get you thinking about how to fill your network vacancies and create diversity in your connections. The best ideas, however, will come from you. Diversifying your network is like diversifying your portfolio—you are investing in a variety of resources. What happens by developing contacts in all sorts of areas is that you become a much more interesting person. New and different opportunities will cross your path, and even if they aren't just right for you, you'll know someone else who would appreciate that intelligence. In the game of business, that's called leverage.

If you really want to maximize your business leverage, take advice from Jill Lublin, author of the bestsellers *Guerrilla Publicity* and *Networking Magic*, and create joint venture alliances within your network to advance your business goals. "What you want to look for," says Jill, "are people who are outstanding experts or visible and respected in their fields." If you have managed the challenge of connecting with someone who inspires you and are expanding your network in a purposeful manner, you may already have some potential joint-venture partners in your network. Creating an alliance is merely a matter of asking for what you want from people with whom you wish to affiliate. Jill has used joint-venture alliances to gain access to large networks as well as products and services that could combine with hers to increase business sales. As you work to expand your network, it would be smart to consider people who could be great alliances. Now, that's *ideal*!

Chapter 5

THE IDEAL NETWORK CLUB

The Test

I've shown you how I've put The Ideal Network System to work for myself and for clients. I've given you some examples and tips, and I've walked you through filling out your own "connect-a-name" chart. I've even had you test the system with the challenge from Chapter 3. Now I'd like you to meet four businesswomen who have employed the system to help them accomplish their goals. They were organized in October of 2006 under the auspices of the Carteret County Chamber of Commerce in Morehead City, North Carolina, to test The Ideal Network System.

Over the course of two months, the women met regularly with me to learn how to use the system to meet their goals. By the end of the two months, it was clear that the group had bonded and was actively involved in helping one another work on projects and through problems. Giving and supportive, this was the perfect group of businesswomen to test a system that is all about personal connection.

With the full support of the Carteret County Chamber of Commerce President, The Ideal Network Club was born! It is my great pleasure to introduce The Ideal Network Club founding members to you, by presenting them exactly as they appeared at our first meeting three months ago. I hope you'll find them as inspiring as I do.

Introductions

Tressa Taylor, CEO of Taylored Interiors

Tressa has been self-employed as an Interior Designer for four years and has just opened her first location in town. From the time she began her business, Tressa's clientele has steadily grown, and now she seems concerned mostly about how to manage her current list of clients, rather than finding new clients.

After discussing what she'd like to see happen in her business, Tressa admitted to experiencing overwhelm with her current workload that includes several smaller projects in different geographic locations. To have fewer "piecemeal" or task projects and more "complete" projects, she would have to attract clients who need an entire space or office designed and decorated, as opposed to just window treatments or bedding, for example.

Accomplishing this would allow Tressa to express her talent more fully, making for a richer portfolio. It would also help her streamline her energies and eventually might present the opportunity to add someone to help her with these more comprehensive projects. Focusing on finding the *ideal* type of client to suit her growing business is goal number one. This goal includes identifying the environments where she'll find these *ideal* clients and creating access to them. (You'll read about how to get into the *ideal* environment in the next chapter.)

Goal number two has been brewing in the back of Tressa's mind ever since she had participated as a designer in a home makeover event televised on a local ABC affiliate the previous year. Though that was a one-time show, Tressa is now "on fire" about the possibility of her creating a similar television show that would have makeovers and interviews, and provide visibility for vendors in her industry. As she talks, you can see the excitement and sparkle in her eyes. Tressa also mentions the rewarding experience she had working on a Habitat for Humanity house several months ago. She is interested in identifying another charitable project that could use her designing and decorating skills.

With her three goals in mind, I began coaching Tressa on categorizing a few of her contacts into *ideal network* categories. Later, I'll tell you what happened.

Now, meet…

Martha Vaughan, CEO of VII Insurance and Investment Services and Registered Representative of Woodbury Financial Services, (LUTCF) Life Underwriters Training Council Fellow

Martha is a home-based professional who comes to the group feeling that she needs some direction. She started her career in the financial services industry in Greensboro, North Carolina in 1988 as a consultant, and then moved to the coast where business was more entrepreneurial, military- focused, and seasonal. She began working with individuals and business owners to protect and build their assets using life insurance, disability, long-term care insurance, retirement products, and mutual funds.

Although Martha is confident in her offerings and intelligence, becoming visible in a small community with a highly competitive market is both challenging and time-consuming. Also, Martha doesn't feel that she is experiencing the momentum that she wants, even though she is involved in several networking groups. She is a perfect fit for The Ideal Network Club!

Now, I have to tell a story on Martha. Just prior to our first meeting, she and I spoke on the phone. I told her to bring her contacts, however she kept them. I thought she might bring a file, planner, or address book. Martha arrives at the meeting carrying a fishbowl filled with business cards!

Don't laugh—there is actually some logic at work here. She had participated in a trade show, and people who visited her booth dropped their business cards in the fishbowl. Business cards now had a permanent home in the bowl, however, and Martha just keeps adding cards rather than attempting to edit the ones that were already in there.

Martha's first goal is to figure out what to do with that fishbowl full of cards. While she also has a planner with daily contacts and a barely-used card file of names that needs organization, it seems

that her fear of "dumping people" from the fishbowl is a greater issue.

Her second goal is to find a publicity or media opportunity that might give her the visibility that she wants. But most important to Martha is her third goal—seeking referrals to *ideal* clients. With these three hefty goals in mind, she set about organizing her contacts.

The first goal is easy. If she had made some follow-up contact with the "people in her fishbowl," then she'd know whether to keep them on a prospect list. I don't advise keeping business cards more than a year for people you have not connected with. A good clue that you are just stockpiling business cards is if you have not transferred their information to a file or an address book.

It would be difficult for Martha to categorize her "fishbowl" card people into *ideal network* categories since she has no relationship with them, and for that reason, they are not useful to her projects or to The Ideal Network System test. With the fishbowl card issue resolved, Martha then turns her attention to other goals. Her success in fact includes a "double win"…but I'll tell you about that after you meet the other women in The Ideal Network Club.

Julie Naegelen, Manager, Membership Services, Carteret County Chamber of Commerce

Since Julie is largely responsible for assembling this group, she has a good idea of our agenda before we meet. Julie's participation is interesting because she isn't a business owner. Her job is all about recruiting and then working with new Chamber members. Her specific goal—one that everyone could relate to and one that she has been working on for a while—is to recruit a new member for the Chamber's Ambassadors Club.

At most Chambers of Commerce, Ambassadors Club members visit other members periodically at their businesses and attend as many Chamber events as possible. Ambassadors are expected to assist in recruiting new Chamber members and helping the Membership Department retain current members. Valuable volunteers like these, with the time and interest to commit to such a significant program, aren't easy to find.

How Julie recruits Ambassadors Club volunteers is like looking for new customers or clients. She has to sell the benefits of the Club, but first, she has to figure out the type of person who will make an *ideal* Ambassador and then categorize her contacts to know the right people to ask for help in finding the *ideal* Ambassador.

Julie's major hurdle is that she has not yet weeded through her predecessor's contacts. Many of the contact cards have incorrect or obsolete information, and there are many names she doesn't recognize at all. In essence, this isn't Julie's network; it is the one she has inherited.

We start by categorizing contacts that she does know. As she gets more comfortable with categorizing new contacts, the network will begin to look more like Julie's. Actually, she doesn't need that many contacts to achieve her goal, but more about that later. Now I would like you to meet...

Debbie Fisher, Sales Director, Mary Kay Cosmetics, CEO of Office Fusion Solutions, Partner in Hyper International and Coastal Heritage Realty and Builders

If you're guessing by reading her business affiliations that Debbie is no stranger to business or networking, you're right. Debbie's evolution as an owner of multiple businesses began when her Mary Kay business was bursting at the seams. She decided to move her growing cosmetics consulting business from her home to an office, but she ran straight into a roadblock—appropriate, affordable space was rare. Being the problem-solver that she is, Debbie developed her own solution, with the help of some smart partners.

Hyper International Business Center was created as an "incubator" to provide entrepreneurs with right-sized office space, a communal kitchen area, conference room, telephone system, and lobby. Office Fusion Solutions was added to provide support services, along with a staff to handle secretarial, bookkeeping, and sales-related work. The flow of clients among the companies in the Business Center began almost immediately. Debbie and her partners had created a self-nurturing environment!

The networking skills that lead to manifesting this kind of business success make Debbie quite the "connector." So naturally someone soon noticed that she would make a great real estate agent. Debbie had made a referral to an agent, who, upon closing the deal, informed Debbie that she could have made $2,000 that day had she been an agent herself. Since only licensed agents are allowed to receive referral fees, and being the intelligent woman she is, Debbie went out and earned her real estate broker's license.

Why would this busy, successful woman want to participate in The Ideal Network Club? Oddly enough, Debbie informs the group during our first meeting that she feels she is the one who is going to need the most help. That seems like a strange observation coming from a woman who's featured in the newspaper so often for being named the Chamber's Ambassador-of-the-Month, her photo is probably on file.

But Debbie's current career focus is a bit of a challenge. Her remarkable success in everything she does points to her determination; however, keeping the motivation going when you are setting your own bar higher can be difficult. Debbie's big goal is to become a National Sales Director with Mary Kay Cosmetics inside of a year. That goal requires Debbie to expand her Mary Kay business with twenty new consultants who want to be Sales Directors. She has a year to do it, but her goal now is to jump-start that effort by finding as many qualified prospects as possible.

Much like Julie's goal of recruiting an Ambassadors Club member to the Chamber, Debbie has to sell the benefits of Mary Kay Cosmetics, but to whom, exactly? Finding those *ideal* people will make the difference between wasting time with women who want to become Mary Kay consultants for all the wrong reasons, and finding women who will become excellent business associates—and who will also be the stepping stones to Debbie's reaching her ultimate goal.

Unlike the others in The Ideal Network Club, Debbie is a multiple business owner, which creates time constraints, but that's where The Ideal Network System can be a lifesaver. Targeted, specific communication will always save time and frustration. With such a huge network of people to draw from, it seems that Debbie

will have no trouble getting a prepared message to a select group of contacts. Her first effort produces some interesting results.

Learning How to "Work" Our Network of Contacts

When The Ideal Network Club was organized, this book was not finished. So, the founding members weren't privileged to have the information that you've read to this point. Instead, I personally guided the participants through categorizing their network contacts using The Ideal Network System. I also helped create e-mail campaigns designed to secure opportunities and leads that were specific to their goals. During this process, it was evident that the traditional marketing mindset was completely established in each of these businesswomen. Looking at their network of contacts in a fresh way and custom-categorizing the names for purposeful use was a real stretch.

It's understandable how easily we get locked into a particular mindset. We often find it difficult to "work" our network of contacts unless we absolutely must, or unless someone offers to help us. Like most businesswomen I've met, The Ideal Network Club members weren't wired to regularly work their network purposefully in order to brainstorm, research ideas, find mentors, solve problems, or collaborate on a project. Networking was thought of more like a public relations activity conducted in a social environment, primarily to find clients or vendors.

Along with changing the mindset of how to view networks and networking, there was also the issue of controlling the organizational process (i.e., categorizing contacts according to the way they could most benefit us). We all have pre-set systems for operating our business and become so conditioned to products, and even relationships, being "instant" or "packaged." Over time, this assumption can cause fears that our own creativity and intelligence is not adequate to organize and manage our business in a way that suits us personally.

First, it's fine to utilize each other's background and expertise for mutual benefit. The Club members became excellent at networking with each other, for everything from valuable contacts

for our children, endorsements, and collaborations, to recruitment for our clubs and groups.

Second, customizing your network is like creating a directory of your own personal staff, and this requires *nothing more than real thought.* How hard is that? It was my hope that The Ideal Network Club members would want to create their own personalized contacts, too.

Being the professionals they are, each Club member managed her own transition into working with the system. What happened was an unfolding of new and old relationships, incredible offerings of advice, customer and recruitment leads, and unexpected opportunities that led to still other opportunities. Many of the results exceeded members' goals or were wonderful bonus opportunities that materialized as a direct result of guiding the energy to flow in the right direction.

As of this writing, it's been about three months since The Ideal Network Club conducted their first *ideal network* activity, and the successes just keep snowballing.

You'll recall Tressa's goals:

- Attract "whole" projects
- Investigate hosting a television show based on interior design
- Find a charitable project that needs her designing/ decorating skills

Tressa's results:

- Endorsement from a past *ideal* client, and a meeting with him to discuss potential involvement in an organization filled with other *ideal* clients
- Connection with a local charity interested in her participation as a board member, and in using her design skills
- Invitation by a studio manager to talk about coordinating/hosting a local television show (exactly like the one she had envisioned)

- "Friendship Star Guard" awarded to her by a National Vice President of the American Business Women's Association for her extraordinary success at recruiting new members (some of her recruits were a direct result of participation in The Ideal Network Club)
- Collaboration with a fellow designer to help manage a client project
- Connection with an apprentice designer for a mentor/ mentee relationship and assistance with workload
- Offer to introduce her to the owner of a local yacht club, in order to gain exposure to yacht owners who may need her services—more *ideal* clients
- Introduction to an art gallery owner who has offered framing services for one of Tressa's professional association projects

Martha's goals were:
- Find a good publicity opportunity or means to attain visibility
- Secure referrals to *ideal* clients

Martha's results:
- Mentor referral and meeting (recent retiree from the same industry)
- New client referral—the "double win"—he bought a $5 million insurance policy, and Martha has already categorized him as a Mentor
- Named the Chamber's Ambassador-of-the-Month, which resulted in an announcement in the local paper and a mention in a "who-to-watch" publication
- Her photo in the local newspaper, the Chamber newsletter, and two area magazines, from a condo development's groundbreaking event
- A mailing list of over 200 *ideal* client leads handed to her by a member of her network

- An opportunity to make a presentation to the largest real estate agency in the area
- Communications instigated with area CPAs, to work jointly with clients on reducing taxes and estate planning
- A request that she take on a leadership role within a local business networking organization
- A request to assist at a major annual business event (great visibility)

Julie's goal:
- One new Ambassadors Club member

Julie's results:
- One new Ambassadors Club member, with five more leads that are being processed
- Increased participation by an existing Ambassadors Club member
- Four new friendships formed with members of the Ideal Network Club
- Seven new Chamber members and ten potential members, as a direct result of interest generated by Ideal Network Club members
- Her own new membership in a professional women's organization (giving her access to several potential new members), and a collaboration between that organization and the Chamber on a fundraising project

Debbie's goal:
- Motivated sales consultants who want to become Sales Director (as many qualified leads as she can find)—she needs twenty sales consultants in order for her to become a National Sales Director within the year

Debbie's results:

- Five new consultants (three or four more are expected to sign within a month)

- Four referrals from her to the Chamber for membership (adding to her Ambassadors Club status with the Chamber of Commerce, which results in increased publicity)

- Three new customers for her other businesses

The results these women experienced are not unusual. They spent just an hour or two putting their plans in motion, making as few as a half-dozen contacts in their first e-mail campaign, and most sent their e-mails the day before we met—yet everyone had good results to report.

I'd be remiss if I didn't include my own results from working with the Ideal Network Club members. Their goals were my goals, but all along, we were helping each other. Besides having their testimonials for The Ideal Network System, all of these women are now in fact members of *my ideal network*. Here are just some of the benefits that I received from networking the "*ideal*" way:

- New client

- National endorsement, local organization endorsement, and a connection to a national corporation to seek endorsement

- Connection to a regional executives' organization that resulted in an offer to market this book

- Two invitations to speak

- Free publicity (ads, Web site links, newsletter write-ups, and a local television interview)

- Personal marketing on my behalf—hand-carrying my materials to two national conferences

- Connection to a fellow writer, who has now become a member of my *ideal network*

- A new professional mentor

- Opportunity to collaborate on a project with a professional who has a mailing list full of my *ideal* client types

In closing, I thought you might be interested in hearing what The Ideal Network Club members had to say about working on this project. Tressa, who started out wrestling with the mindset shift, had this to say after her initial results: "I will now be able to look at my connectors through a new set of eyes." Martha exuded an "excited" energy when she reported her early success. "First of all," she says, "the experience with The Ideal Network System and the Club has helped me bottom-line and just get to the point! When you see beyond names and think about what they mean to you, it creates a more open aspect of communication—one that is more eventful."

Julie, who values the timesaving aspect, vowed to organize more mini e-mail campaigns with other specific goals. "The Club has made me think differently about how to proceed in looking for prospects, both for the Chamber and for the Ambassadors Club." Debbie commented, "The Club got me refocused to head in the direction I need to go in. Thank you!"

The Ideal Network Club pilot group requested to move forward with making the Club an official opportunity offered exclusively through the Chamber. This original Ideal Network Club now serves as a model, designed as an income-producer for other Chambers of Commerce throughout the nation. Information about how to form an Ideal Network Club can be accessed at www.theidealnetworksystem.com.

Chapter 6

GETTING YOURSELF INTO THE IDEAL ENVIRONMENT

A few years ago I had the opportunity to meet an extraordinary woman. Her larger-than-life personality, commanding demeanor, and famous name made her quite the sought-after connection. Actually I didn't just *have* the opportunity; I *created* the opportunity. I was drawn to the qualities this woman possessed and knew that her network would be very much like her, just exactly the *ideal* connection for me, professionally and personally. What went into making this experience successful for me may be important for you in making valuable connections to *ideal* clients, mentors, and other significant relationships. Here are some tips for creating your own opportunities:

1. Know the types of people with whom you wish to connect, and why. Consider the people that you attract naturally. Are they outgoing or quiet? Are they creative, curious, contemplative, tentative, or intellectual? Which qualities do you like best? Which qualities make you feel compelled to spend more time with the people who possess them? These are the ones you would like to surround yourself with in order to grow in spirit, skill, charity, profitability, and intellect. Understanding why you wish to connect is key because the connection must serve a positive and elevating purpose. You must be willing to be everything you want these new network members to be— giving, supportive, loyal, and so on.

2. Once you know with whom you'd like to connect, collect information about their professional and volunteer work, clubs, hobbies, and professional organizations. You can find a good bit of information by reading newspaper articles or checking online biographical data. Ask connectors in your network who may know them. Educate yourself in the same way a journalist would prepare for an interview. If your *ideal* connection has written books, read them. If the person gives lectures, attend them. If he or she has a Web site, review every page. Where they spend their time, energy, and resources is their environment.

3. Choose one aspect of their environment that interests you and get involved. Join that organization, buy that club membership, take that class, become active in politics, or volunteer to serve on that committee. Break out your yoga clothes or tennis rackets or become a regular at that particular spa or coffee bar. You'll know the *ideal* fit when you find it.

4. Review your *ideal network* for contacts who might assist you in getting into the environment, who can be on the lookout for opportunities, or who could even have you tag along when they get invitations to preferred events.

5. Once in the environment, be open to all connections. Make yourself known by sharing your skills, intelligence, talents, and contacts whenever appropriate. What you have to share will attract *ideal* connections and pave the way to the person you seek.

Much of what is listed here is just common sense in everyday networking. What usually stumps people in the process of moving forward is the fact that purposeful, focused planning is involved. This process is not something you push or try to control, and I always find myself reminding people who are starting a project to begin with what they already have. The Ideal Network System helps you to know exactly what resources you already have in place to help you move toward any goal or into any environment.

Speaking of quest—since what you wish to do is key, let's get you right to the point of exploring your specific *ideal* environment.

And since I'm counting myself as a member of your new *ideal network*, I'm providing some worksheets, starting on the next page, to help you out.

Getting Into the *Ideal* Environment

Worksheets

This is a step-by-step guide, with you literally providing the guidance. By filling in the blanks, you will identify and create a path to an *ideal* environment using a role model as a focal point. This particular worksheet is designed primarily for the person who is making a work-related change or plan. You can adjust this worksheet as you like to accommodate other *ideal* environments. This can be used alone or in addition to the connect-a-name chart. Keep your *ideal network* contacts nearby for reference.

1. I want to:

_____ because

(Fill in goal)

(Fill in why)

2. Achieving my goal will require particular expertise, skills, assistance, and resources, such as _____

3. People who have the expertise/skills/resources or know how I can get them are:

_____ _____

_____ _____

_____ _____

_____ _____

(In lieu of names, I can list titles such as "banker." Include phone numbers or e-mail addresses.) These people are my resources.

4. People whom I know (or know of) who have achieved my dream/goal are:

_____ _____

_____ _____

_____ _____

(Include phone numbers or e-mail addresses.) These people are my role models.

5. I can find these role models by exploring or connecting with: _____

(Fill in names of professional associations, clubs, businesses, events, and other places or groups where these role models can be found.) This is the environment where my dream lives. Wherever these successful people are, the clubs they belong to, the events they are keynoting, whatever social functions they attend—is my *ideal* environment.

6 I can get into these same environments by taking these action steps:

Contacting _____

Researching _____

Attending _____

Joining _____

Offering my talents/skills to _____

Enrolling in _____

Signing up for _____

Volunteering for _____

Introducing myself to _____

Asking for an introduction from _____

Introducing _____to_____

Sending information to _____

Asking for information from _____

Having lunch with _____

Telling what I want/need to _____

Requesting an appointment with _____

Preparing _____

Acquiring _____

(Fill in specific actions with my own creative ideas. Use names from the previous page and my *ideal network*, where appropriate. Include contact information.)

The most important action from the list I've developed above that will help me get into my *ideal* environment is:

This is my action plan.

Once you complete it, this guide sheet should reflect:

• Your goal or dream

• What resources will be necessary for accomplishment

• A list of people who will help you with those resources

• A list of role models for advice, motivation, and inspiration

• Places where you'll find role models

• A list of actions to get you into your *ideal* environment

Need some encouragement? People who have already "navigated the jungle" are the keepers of your dream. You'll do it differently, perhaps better, but they have the tools that will help you cultivate and nurture the process of achievement. It will be the same for those who follow in your footsteps.

Here are a few more resources for exploring *ideal* environments:

• Local Community College: Check out curriculums, including continuing education—or investigate

possibilities for teaching. Many community colleges pay community resource teachers. You're not going to get rich, but the best way to learn more about a subject is by educating others. If academia is a new scene for you, this could be a truly eye-opening experience, and one that could lead you into interesting directions. By teaching, you may find yourself assuming facilitator roles, conducting workshops, or taking on writing projects in other environments. The types of people with whom you'll connect could enrich your life with opportunities to expand your knowledge base. Any environment of learning is going to produce great rewards.

- Local Civic and Community Organizations: Municipality Web sites often provide links or listings in your area for these organizations. Investigate ones of interest to you.

- Chambers of Commerce: Chambers hold regular networking events that you can attend as a guest of a member. Self-employed memberships are usually quite affordable. See Chapter 9, "Primer: 31 Ways to Use your Chamber of Commerce to Help You Succeed."

- Philanthropists: Every community has people who are known to give large amounts of money through their foundations to charities. Getting to know them, and their organizations, can be educational and can open up possibilities you've not considered. Offer to volunteer with some of their charities.

- Cable Television: If you suspect media could be of interest to you, check out the local programming for the cable television station in your area. Consider getting booked as a guest on a show or check into hosting your own. There's usually no pay, but loads of visibility, experience, connections, and new opportunities.

- Nonprofits: The IRS has a publication that lists all charitable nonprofit organizations. Visit their Web site at www.irs.gov and download Publication 78. Investigate the organizations that interest you.

- Special Events Editor: The special events editor for your local newspaper generally knows about present and future fundraising events, concerts and talent shows, as well as business and political events. A conversation with him or her could reveal a wealth of opportunities to connect with an *ideal* environment.

- Political Organizations and Events: Political events draw such a diverse group of people. You have all walks of life and a variety of different professions involved. You'll hear a lot of talk about current issues. Generally, those people who are more involved will get a chance to help and make a difference when the candidate wins. Even if politics doesn't interest you, you can't lose by showing up at the many functions that occur during "season." Where else are you immediately valuable upon entering a room? Your vote, your opinions, your skills, talents, contacts, and yes, your money, is greatly appreciated in this environment. With so much power in your corner, you'll easily meet interesting new people and perhaps find an *ideal* situation or connection.

- Your Local Golf Course: Golf is a sport with a special environment that allows for socialization and business simultaneously. The National Golf Foundation reported in 2004 that one-fourth of adult golfers in the U.S. are women, further stating that women golfers are the fastest-growing segment of new golfers. Golf is as much about networking as it is competition, making it a perfect choice for the businesswoman. The benefits, however, extend beyond work-related interactions. According to a 1999 study conducted by The Women's Sports Foundation, women golfers possessed the highest physical and mental health of all study participants. Donna Lopiano, Executive Director for The Women's Sports Foundation, wrote a publication entitled "Why Women Should Learn How to Use Golf (Sport) for Business." Updated material from that publication, along with resources can be found at the organization's Web site, www.womenssportsfoundation.org.

Do you recall the experience at the beginning of this chapter where I "attracted" the superwoman I wished to meet? That meeting came after two fumbled attempts. (Even a seasoned pro drops the ball once in a while, but we learn.) I discovered that I could offer this woman an opportunity that no one else was offering—specific television publicity for her favorite charity. The lady is known for her philanthropy, but she also happens to be the sister of legendary financial wizard, Warren Buffett. When the connection was finally successful, it became an experience that was effortless and enjoyable. The most amazing connections usually are. The *ideal* ones always are.

Chapter 7

THE GENIUS POOL

"My chief want in life is someone who shall make me do what I can."
–Ralph Waldo Emerson, American Poet and Essayist

They teach us. Some gently shove; others kick us in the butt. Some are relentless in expectations, while others support us by guidance and handholding. They are often the ones for whom we create. Their passion to bring out our best is life affirming and as critical to our being as water. I speak of the mentor.

You will recall a few chapters ago when you discovered that mentors are a must-have in your *ideal network*. Like a collection of fine antiques, your mentors will become the shining jewels of your new network foundation. But, it is in the collecting of such treasures that you build your networking muscles.

You most likely already have a mentor or two, even though you currently think of them as business gurus. But how do you really know if someone is mentor material? You know by the inescapable feeling of awe she evokes in you. It may seem that she has discovered something about life that you've yet to learn, but really want to. It could be that you've not actually met, and that's okay; this person is still "your mentor." In your *ideal network*, a group of mentors are called "The Genius Pool."

Connecting with mentors is like meeting with saints—you come away not only informed, but also inspired, renewed, and motivated. The connection runs deep, as it must. I believe that God has provided us teachers and guides our entire life in one form or

another, but as we grow older we learn to look for them. When the light along our path dims and the direction ahead seems unclear, we look for a visionary to point the way. But what we find is something much more—not just directions, but a tapping of the soul.

I want you to consider your dream—what you want from life— what you wish for, personally and professionally. Understand what moves you deeply, and then remove all obstacles to achieving it. See what names pop up for you who could be potential mentors— people who have that dynamic power to affect you and others like you. If you can't come up with exact names right now, try again later. We usually have in or around our lives precisely who we need, even if a person isn't currently in our *ideal network*, or if they are just a face on television. What type of person do you really want as a mentor? Perhaps someone who is successful at creating an Internet-based business, or maybe an entrepreneur who manages several businesses would inspire you to get cracking on a business idea of your own. Keep the awe-factor in mind and understand that you are, in essence, recruiting a "teacher." If you already have a mentor, more than one would be better—because we are after *"ideal"* and *ideal* means that you have a Genius Pool.

Check the next page for another set of worksheets to help you find your own saints.

The Genius Pool Worksheets

What if you had the opportunity to sit down with a multimillionaire or a world- famous musician and pick his or her brain for an hour? Can you imagine what you'd feel like for the rest of the day? Would spending time with a marketing whiz impact your business? How about having a conversation with an award-winning author whose creativity and intellect just blow you away? These are the moments of greatness—when light bulbs turn on, hearts pound from excitement, and the pen you're holding can't write fast enough. People who reach into your inner self and pull your imagination straight from your gut are mentors. You must have them as surely as they must have you, because mentors learn from and are motivated by those that they have inspired. It's much like the relationship between teacher and student or entertainer and audience.

We're defining mentors as being somewhat different from role models, although they are similar. A role model will be someone who has been successful in achieving specifically what you wish to achieve. If that is their only draw, then they remain only a role model. But, if they also possess special qualities you admire greatly and you feel a magnetic pull to be in their presence, then they are a mentor. The defining element for a mentor is whether or not the person inspires you, so your mentor could be a speaker who knocked your socks off at a conference last year. It could be a musician who communicates with you through his music or a stockbroker whose intelligence about wealth building is an exciting resource for you. Keep these thoughts in mind, and let's find some mentors.

A good way to select the best mentors is to list those people you know who fit the above description. Basically, who "juices" you, and why? You can always consider qualities you'd like in a mentor before actually coming up with a name. Talk with some of your network members and see who they suggest. Revisit files where you've saved congratulatory notes or where you keep information on past projects. When you've formulated some ideas, list four here:

Mentor: Why:

_____ _____

_____ _____

_____ _____

_____ _____

Tip: Although I've indicated that proximity isn't critical for benefits to occur, the best mentoring obviously happens if there is personal contact. So, for this exercise, try to make your mentor selections as local as possible

Perhaps you have a couple of people on the fringes of your life that fit—but you're a little intimidated by them. It is time to bring them to the table, so to speak. Make your association with them a bit more purposeful—regular chats, a lunch here and there, sharing

contacts, and so on. You need some face time, not just to glean information, but also to soak up everything around them. Mentors tend to carry their atmosphere with them. They get interrupted at lunch by interesting people that you'll get to meet. Sometimes they carry extra business cards of their associates, or will point out items in the newspaper that may be tucked in the book they're toting around. You don't have to tell them that you've selected them as a mentor, but, if you do, you'll get far more from them and they'll enjoy and respect the interaction, too.

So, pick one of the four candidates you've listed above and decide how you'll connect with them. Check off one of the following suggestions, or add your own.

1. Call and ask for an appointment or a lunch meeting.
2. Contact a member of your ideal network who knows the mentor and ask him or her for an introduction.
3. Send a letter of introduction and request a meeting.
4. Write a letter of introduction requesting a meeting and have someone who knows the mentor deliver it for you.
5. Call the mentor's secretary and request a telephone appointment. During the telephone appointment, ask for an in-person meeting, when it can be arranged.
6. Send an article about the mentor to him or her with a note of appreciation and a request for an opportunity to meet or talk over the phone.

Write your ideas here:

Tips for your meeting:
7. Have a small, pocket-sized pad of paper and a pen handy.
8. Bring business cards with you.

9. At your meeting, and when you meet anytime afterward for the purposes of connection, ask the mentor for contacts who might assist you with a current project.

10. Thank the mentor. After the first meeting, send a handwritten note.

11. Share contacts or information you think would be helpful to your mentor.

The following resources are meant to help you further understand the "official" mentoring process and make good mentor/mentee connections.

For Information/Training/Networking and Mentoring:

- International Mentoring Association
- Professional Coaches and Mentors Association
- International Coach Federation
- Big Brothers/Big Sisters
- Communities in Schools

Professional associations and organizations that offer or promote mentoring programs:

This list isn't intended to be comprehensive in scope, but rather is offered to entice you to conduct your own search. These are examples to help you think about first steps in making mentor connections. Investigating similar sources may turn up some interesting possibilities that lead you to a perfect mentor/mentee fit. As always, when conducting research, take care in checking sources thoroughly.

- Lawyers (State Bar Associations)
- Photographers (American Society of Media Photography)
- Speakers (National Speakers Association)
- Nonprofit Community Leaders (American Society of Association Executives)

- Artists (American Craft Council)
- Researchers (Association of Independent Information Professionals)
- Entrepreneurs (S.C.O.R.E.)
- Professional Women (American Business Women's Association)
- Career Counselors (National Career Development Association)
- Pet Sitting (National Association of Professional Pet Sitters)
- Hispanic Professionals (Hispanic Alliance for Career Enhancement)
- Tax Preparers and CPAs (National Association of Tax Professionals)
- Webmasters (The World Organization of Webmasters)
- Women Writers (The National Association of Women Writers and The InfoMarket Network)
- Court Reporters (National Court Reporters Association)
- Park Rangers (Association of National Park Rangers)
- Self-Employed Persons (National Association for the Self-Employed)
- Real Estate Agents (National Association of Realtors®)

All resources are available through Internet search.

I want you to be motivated and to understand the absolute necessity for mentors. Almost every person who has a great impact on the public, who finds a place in our history—has had a mentor:

- Robert McNamara (former U.S. Secretary of Defense), mentor to Lee Iacocca (former president of Chrysler)
- Ellis Marsalis, Jr. (musician), mentor to Harry Connick, Jr. (musician)
- Donald Kendall (former CEO of PepsiCo), mentor to John Sculley (former CEO of Apple)

- Richard Burton (actor), mentor to Sir Anthony Hopkins (actor)

- Fred Gaisberg (EMI Records), mentor to Isabella Wallich (first female record producer)

- William Le Baron Jenney (architect and inventor of the term skyscraper), mentor to Louis Sullivan (father of modern U.S. architecture)

- Donald Spencer (pioneering U.S. mathematician), mentor to John Nash (Nobel Prize-winning mathematician)

- Dr. Arthur Walker (Stanford University physics professor), mentor to Sally K. Ride (first woman in space)

- Lee Strasberg (drama coach), mentor to Ellen Burstyn, Martin Landau, and Steve McQueen

- Johnny Carson (talk show host), mentor to Garry Shandling and Jay Leno (comedians and talk show hosts)

And has also been a mentor:

- Muddy Waters (musician), mentor to Buddy Guy (musician)

 Buddy Guy, mentor to Eric Clapton, Keith Richards, and Mark Knopfler (musicians)

- Buster Keaton and Red Skelton (comedians), mentors to Lucille Ball (comedienne)

 Lucille Ball, mentor to Carole Cook (comedienne)

- Peter Lassally (television producer), mentor to David Letterman (comedian and talk show host)

 David Letterman, mentor to Rob Burnett (producer)

- Lionel Hampton (musician), mentor to Quincy Jones (music producer)

 Quincy Jones, mentor to Tamia Washington (singer)

- Benjamin Graham (professor, author, and investment executive), mentor to Warren Buffett (investment expert)

 Warren Buffett, mentor to Joe Mansueto (founder of Morningstar—financial investment research)

Many of the pairings listed above are courtesy of Rey Carr of Peer Resources. You can find out more about mentoring and famous mentor/mentee matches at his Web site: www.peer.ca/peer.html.

Sometimes a mentoring situation impacts you so much that the experience inspires you to reach out to others. You may not even be aware that what you are doing is actually mentoring. In some of the examples listed above, mentor and mentee may not have met, yet the connection was instant and strong. Joe Mansueto, who only met Buffett briefly on one occasion prior to starting his own business, attributed the writings of his world-famous mentor as the primary source of inspiration. The incredible impact of Graham's teachings on Buffett pushed him beyond business success into publishing his intelligence—in a sense—teaching. No doubt Mansueto has done the same somewhere in his life. Mentoring that results in millions of people being affected happens when the mentoring experience of receiving and passing along information or inspiration becomes complete and is acknowledged as a part of one's life's work.

Nobody understands the concept of mentoring better than Oprah Winfrey. Those who have mentored her along the way proudly watch now as Oprah reaches out to people around the globe, teaching charity, inspiring dreamers, boosting educators, and sharing hope. This she does in a thousand different ways—not just through her television show, but with her Angel Network and Book Club. Then there's Oprah's Child Predator Watch List to help protect children, the work she's done in poverty-stricken countries, and the relief she's provided for hurricane victims. Add to that the careers she's helped to launch over the years, and the people who are successfully marketing their talents, battling tough medical situations, donating to charities, or starting nonprofit organizations and living better lives because Oprah has mentored them. She leads and inspires, of course, but she also teaches by providing specific information and connecting her mentees with experts and role models. Whenever possible, she personally lends her own support. And, because her ability to mentor at such a high level with that kind of trickle-down is nothing short of miraculous, I call this type of mentor chain "The Oprah Succession."

In 1944, Gertrude Elion began work as a scientist at Burroughs Wellcome in Research Triangle Park, North Carolina. One of only two women out of seventy-five staff members, the tiny, vibrant "Trudy" would collaborate with her mentor, Dr. George Hitchings, to discover the first effective drug that induced remission in childhood leukemia. For that achievement, she and Dr. Hitchings received the Nobel Prize in Medicine in 1988. If you had asked Dr. Elion why she became a biochemist, she would have explained that it was a mission of love to help protect others from the fate her beloved grandfather suffered after a long battle with cancer. The awards and achievements are so numerous for Dr. Elion, they cannot all be cited here; but what is special to note is that she considered one of her best achievements to be mentoring. Her nephew, Jonathan Elion, M.D. says, "When she was a visiting professor at Brown, she didn't want to meet with the VIPs and department heads; she asked to arrange for time with the students."

I personally was so touched by Dr. Elion's accomplishments and her ability to inspire that I set up a field trip and took a group of young people to meet this seventy-something "fireball." As she passed the replica of her Nobel Prize around for everyone to hold, she gushed about the excitement at the ceremony when the award was bestowed on her. You could see the genuine delight she had in speaking with these students, and they were thoroughly taken by her wit and enthusiasm for her field. When it was time to leave, not a single youth departed without giving her a hug. Nor did I. Dr. Elion died at the age of eighty-one, leaving an indelible mark on the fields of science and medicine and on the lives of those she helped to save and those she inspired to save others. Appreciation goes equally to Dr. Hitchings, who recognized the "giant" who arrived at his lab in 1944 and gave her every opportunity to succeed. The knowledge he passed along to her, she has passed on to a multitude—and so it continues.

Mentoring is important. It should be a commandment. But, changing lives doesn't require that you be a Nobel Prize winner, and you don't have to view it as your mission to inspire masses of people. All it really takes is interest and heart. The parents of a young lady I know credited the girl's high school mentor with

helping their daughter to emerge from her shy self into a girl with a vision. That vision included an interest in politics. The year of her transformation, she visited the Governor's Mansion on a field trip and surprised classmates when she informed the state's First Lady that she wanted to be a Congresswoman some day. Within months, our young lady ran her first campaign—for a student office. She studied law after high school, and utilizing her best connection (the state's First Lady), she secured an internship in a Congressman's office in Washington, D.C. Having completed her doctorate, that young lady is now a lawyer in New York City. I don't know about you, but it sounds as if she's already succeeded.

Our future Congresswoman's mentor is rightfully proud and believes that his mentee's achievements are his own reward. I've kept every note from a young person whom I've mentored, reviewing them when I need to "fill up my heart." Along with being appreciated for even the smallest gesture of support, my own gratitude at feeling worthy to share my mentoring skill keeps me looking for opportunities to do more.

In my life I have had mentors who have made a difference without my even having met them. A set of motivational tapes by a professional speaker provided me with the encouragement I needed to act on creating my first youth leadership program, the one charted in Chapter 3. I listened to those tapes over and over again, each time gaining clarity and determination. Also in Chapter 3 is a chart for securing an *ideal* client that I wanted. The public relations situation that prompted my connection with that client was what I refer to as a "gap." Just before this event occurred, I had completed reading a great book that taught entrepreneurs to look for a gap where service can be provided. I was looking for the gap before it showed up, thanks to the author, motivational speaker and mentor, Mark Victor Hansen.

On any given day, members of my own Genius Pool, with whom I can connect to learn, and to feel supported and inspired, are accessible to me. I ask to meet them for lunch or call them when I need a sounding board. I love hearing about their projects, because my mentors tend to be energetic, driven people who are always involved in something interesting. Being around them "feeds" me. I need it like I need sunshine. So do you, and so does everyone.

The mentoring relationship allows you to understand the deeper value of human connection. Unlike daily networking, where connections are more casual and intellectual, mentoring is a special kind of networking with lifelong benefits. In this chapter, I'm recommending that you have the whole experience, as both mentor and mentee. I am convinced that doing so will advance your goals and help you keep your network *ideal*. Find three or four mentors and organize them into your *ideal network*. Make contact with them regularly. They are your Genius Pool and will provide expertise, ingenuity, and connections. Accept the mentoring experience with grace, and mentor others who will benefit from your expertise.

Whatever talent you need to share with the world, there is charity in it—that talent is where your greatest deed lies. The potential for sharing is what gives reason for the talent in the first place. What you do individually for people eventually becomes collective. What you do in a public way to serve becomes part of history: an organization's history, a town's history, and a family's history. It is your legacy.

Chapter 8

25 IDEAL NETWORKING TIPS

As promised, here are twenty-five more ideas on how to generate new connections or make the most of networking opportunities. If you've heard some of these ideas before, that should be a good sign that they work and are worthy of your attention. As I instructed before, it's generally best to try that which fits your personality, but don't be afraid to push yourself into unknown territory.

Here we go…

1. Post on Internet message boards or blogs. You can communicate with people from all over the world. These days, more and more people are finding business associates, life partners, and even clients by using Internet forums. As in all Internet communications, be cautious about where and what you post. It's your responsibility to protect yourself.

2. Conduct a survey for marketing research for yourself or someone else. Create a questionnaire, find a group of people, introduce yourself, and ask away.

3. Help a friend look for a job. Make a few phone calls indicating you are researching area job opportunities for someone. You get to know more about area businesses and your friend gets job possibilities.

4. Submit articles you've written to Internet ezines and free content sites. People who identify with your subject will connect to you. I like www.ideamarketers.com. The first

article I placed there several years ago garnered over 500 readers within three days. That article and others I placed on that site were picked up by online newsletters and Web sites and included my name and Web site address. Some of those articles are five years old and still available on the Internet. There are lots of article sites that you can find with a search using keywords like "article submission sites."

5. Encourage someone in your network to start something new and offer to help. Ideas: (neighborhood coffee or wine-tasting, pet rescue, or a reading program for nursing homes). Volunteering in general is always a great way to network, but if you get someone else involved at the same time, that's even better.

6. Be wherever the music is on a weekly basis. Nothing pulls people together like food and music, and there's probably a band playing near you almost every other night. Make it a point to mix at area performances regularly.

7. Collect recipes—even if you don't cook. Ask your network as well as people at the grocery store, gourmet shop, kitchen store, restaurants, deli, health food and Asian market.

8. Write letters to old friends. Reconnecting can often bring to light some interesting information and ideas.

9. Become the photographer at events and gatherings. Ask a person's permission to take the photo. Then say you'd be happy to send or e-mail them the photo. Or hand them your business card and tell them to visit your Web site the next day to view all of the photos. This pulls traffic to your Web site.

10. Share your plant cuttings or veggies and flowers from your garden with neighbors or people in your workplace whom you don't know very well. Tuck a note or your business card inside. Nice icebreaker.

11. Carpool. Take advantage of business trips and meetings by carpooling with people you don't know.

12. Join a card game in your neighborhood or play online.

13. Go out to a local park and take regular walks or jogs where you know there will be others. Take your dog, and you'll connect with whoever is out there with another dog. Fido will see to that.

14. Do a mini e-mail campaign (mentioned in Chapter 1) to your overall network, indicating the type of person/people with whom you'd like to connect. It's like shopping at different stores. It will be fun to see what comes back to you. Instead of e-mailing asking for a specific type of person, you can e-mail explaining a situation for which you need an expert's help and see who your network recommends for you.

15. Use the weather to help you decide where to go to connect. Rainy or cold days could be great for grabbing a coffee at a busy bakeshop. You'll be among others who are avoiding the elements. You could also visit a museum or a mall. Beautiful, sunny days will be nice for enjoying lunch in an outdoor mall or park, where you'll run into other sun-lovers. Head for the nearest garden center or flea market. Your icebreaker is the weather, of course.

16. While on vacation, make it a point to get to know some locals at your destination. You can converse with cab drivers, wait staff, a hotel concierge, tour guides, or shop clerks. You'll get to know some of the best places to visit in the area and perhaps run into some interesting connections.

17. Wear or carry something just a bit different and go where you will be seen. It can be an unusual vintage brooch, a hard-to-find bestseller, a fabulous silk scarf, or even a fresh flower tucked behind your ear or in a jacket lapel. You'll attract people to notice, which makes for an easy introduction.

18. Become a "contact" person for a project, committee, event, or club. Getting yourself on a "who to call" list means that your name and phone number will be published in directories, on Web sites, and in newsletters. Since the people who will make contact will relate to the purpose of

whatever you are representing, be sure those are the types of people with whom you'd enjoy connecting.

19. Hire a professional networker to make connections for you. If all else fails and you cannot see a first connection within your own network, you can hire someone to make connections for you. As someone who does this occasionally for clients, I can tell you that the person you hire needs to be skilled, outgoing, and have a strong and diverse network herself. There are particular situations that lend themselves to hiring a pro. It works when the client is looking for: a job, a publicity connection, a particular decision maker, a connection to an industry outside of their reach, advice on a particular subject or career, an agent or recruiter, and even types of organizations to join. It can often be easier for a non-invested middleman to make complicated connections, and then you will follow up personally with whatever connections the professional networker makes.

20. Treat your network. When you are reconnecting with people, making them feel special is a great memory-maker. What you offer doesn't need to be expensive. A seashell that you found on a morning beach walk and handed to someone at lunch works just fine. When I bring some favorite chocolate candies to people I know like chocolate, they start smiling the moment they see me. Homemade cookies will always get attention. I love getting free samples, a single garden flower, picture post cards, and fresh strawberries. A woman once gave me a "good luck quarter" just before I got up to speak at an event. A businessman I met gave me a moon rock found on the site of a landmark pier that is being demolished. I could tell by his melancholy that he viewed the rock as a sort of remembrance item, so his sharing was particularly significant. When I see him again, I have no doubt that we'll recall one another. It's just a way of connecting that goes beyond a handshake and a business card.

21. Partner with someone. If you are the least bit shy, get someone to circulate with you at events. You'll want to

make sure that your partner knows some people at the event to make introductions. If you cannot find a partner, then let your event host know that you don't know anyone in the room. Ask to be introduced to someone who is familiar with those in attendance. In most cases, it would be inappropriate to expect the host to make introductions, but whomever you are paired with will be able to handle the job. That person could become a "connector" in your *ideal network.*

22. Hold your own personal "Business Card Day"—a day where you hand out your business card with a special offer. Make sure you are already booked for lunch and have lots of errands to run that day. Pull out twenty or more business cards and jot a note on the back for an outrageous discount or free-service offer. The idea is to make it really special, because you only do "Business Card Day" once a month, or once a quarter. Hand your cards to waiters, dry cleaner attendants, sales clerks, hairdressers, bank tellers, and anyone with whom you come in contact, and tell them what you're doing. They can keep the card or pass it along. Graciously accept any business cards offered to you in return. This is as much a marketing idea as it is a good networking technique, but it can be a fun way to meet new people.

23. Become a volunteer assistant for a local event planner. You'll find professional event or wedding planners in almost every community. Networking with them could gain you access to their vast network of vendors and clients. Consider if you might have a product, service, or talent that could be useful to an event planner. Meet with them and negotiate a collaboration that will swap what you can offer for access to their lists. You can also simply volunteer to assist at events as long as you are allowed to wear your own nametag. You don't want to be standing at the door handing out your business cards, but should an event attendee be interested in your business, you could collect their contact information and follow up later.

24. Congratulate award winners. Whenever you are at an event where awards are presented, be sure to take note of the

names of the recipients. You can congratulate them in person at the event, and then follow up with a nice note that includes your business card.

25. Introduce The Ideal Network System to someone else. Share this book with a kindred spirit or better yet, throw an Ideal Network Party. You can download the "how-to" at my Web site: www.theidealnetworksystem.com. (See the offer in the introductory part of this book.)

Choose what you believe will work for you and get moving. The Chamber of Commerce Primer starting on the next page may be your best resource yet for networking.

Chapter 9

THE PRIMER

31 Ways to Use Your Chamber of Commerce to Help You Succeed

A local Chamber of Commerce is your one-stop source for all things business. The resources you can expect from a Chamber range from business advice to membership directories, mailing lists, advertising deals, networking, and publicity opportunities. The Chamber of Commerce is also set up to serve its membership as a community leader, a collective voice for business when it comes to government and legislative matters. As a non-member, you should be able to attend most member functions as a guest of an active member. Talk with your local Chamber staff and collect whatever resources may be free to you as a non-member. Membership fees for individuals, self-employed persons, and nonprofit organizations are generally quite reasonable, and some Chambers will swap membership for a service or product.

You simply cannot go wrong by joining your local Chamber of Commerce. I highly suggest considering membership. But whether you are already a member or planning to become one, you do need to know how to maximize your investment. Here are thirty-one ways to do just that.

Some offerings may vary from Chamber to Chamber, so ask your Chamber staff for information. If they don't offer what's listed below, they may be able to come up with an alternative. Fees or criteria could apply to some suggestions.

1. Ask to appear on your Chamber's local television show.
2. Place your brochure or business cards in the Chamber lobby.
3. Put a blurb about your business in the Chamber newsletter.
4. Include that you are a Chamber member on all of your printed material and in your marketing efforts.
5. Advertise in the Chamber's membership directory.
6. Get involved in one or more Chamber committees. (The Ambassadors Club or Membership Committee are good ones that get you connected to other members.)
7. Attend all ribbon cuttings, grand openings, and after-hours events that you can. These are generally monthly scheduled events that include refreshments and open mingling.
8. Ask to volunteer to work the front door at Chamber events. You'll get to meet everyone who attends.
9. If you'd consider a leadership position, perhaps you'd like to serve as a committee chairperson or as a member of the Board of Directors. A Board position can be an instant credibility booster, but be sure that you really want to participate. You don't want to be one of those Board members who just needs the title for your resume. Smaller boards consist of about twelve to sixteen people, and elections are usually held yearly for several seats.
10. Sit down with the Executive Director/President of the Chamber or the Membership staffer over lunch or coffee and conduct a little brain-picking. These are the connectors of the Chamber. They know the businesses, events, and news of the day. While you've got their attention, inform them of any new projects, business ideas, or services on which you are working. Their advice, leads, and referrals could add up to some nice results for you. I had a member who did this kind of networking with me regularly, and because he offered unique services, I was able to recall our conversations and send him quite a bit of business.
11. Purchase a mailing list. Most Chambers will sell their membership or relocation request lists to members already on labels.

12. Unless your Chamber has a rule about wearing only the nametags they provide at functions, create your own. The one I liked best was when a Chamber member pinned his business card to his shirt. The card was both colorful and informative, making for a nice conversation starter.

13. Check with the Chamber staff to discuss potential collaborators or project partners. When my Chamber of Commerce held a trade fair, I encouraged compatible businesses to rent a booth and promote themselves together. Some actually continued that collaboration after the event.

14. Use the Chamber conference room for your workshops, meetings, or trainings, if you don't have an office or storefront operation. Most Chambers will offer their space free or at a discounted rate to Chamber members. They should also let you hold your ribbon-cutting event at their location in the case your space isn't appropriate. Here's pretty much how a ribbon cutting works: The Chamber does the inviting and usually contacts the media or at least gets a photo of the event into the local paper. You'll give away something at the event, such a sample product or gift certificate for one of your services, in order to collect business cards from attendees. The Chamber provides the nametags and you provide the refreshments. Some Chambers charge a small fee to cover their costs.

15. Check to see if your Chamber has partnership arrangements with a long-distance carrier, cell phone company, or insurance provider. Some Chambers engage in affinity programs and group plans that they offer to their members.

16. Check to see if your Chamber offers a member-to-member discount program, whereby you could receive dollars off on goods and services provided by other members. You may want to participate as a provider.

17. If your Chamber has a Web site, make sure your listing is correct. Unfortunately, there are those Chambers (just like there are those businesses) that are lax about keeping information current on their Web sites, so you need to keep the staff updated on changes in contact information, particularly e-mail addresses. Some

Chambers offer their members an individual Web page on their site. If you don't have your own Web site, this could be a good thing. If you do have a Web site, maybe your Chamber will provide a link to it with your listing. If so, expect a small fee, but do it! Anybody who is looking up businesses in the Chamber's online membership directory will appreciate being able to link directly to you. If you and five others are listed under the same category, those with direct links will get the action.

18. If you are just starting a business and trying to fill vacancies in your *ideal network*, make an appointment with the Chamber's Membership Staff and ask whom you should get to know. Have paper and pen ready.

19. Sign up for "Operation Thank You," if your Chamber conducts this annual member appreciation event. It is usually a daylong or sometimes a weeklong activity involving the delivery of membership directories and decals to members. It will get you in the door of several businesses, with your smile and a "thank you." Who doesn't love that!

20. Chambers often hold monthly or quarterly luncheons that usually includes a speaker who informs members of events that could impact business. If they don't already do so, ask the Chamber to institute a two-minute commercial period at the beginning of the luncheon for members to speak about their business. The crowd will quite often be larger than you find at ribbon cuttings, so your commercial will hit a wider audience. You will want to congratulate any new members and give them your card after the luncheon.

21. I have another tip for you if you are on the leadership path or have political aspirations. Chambers across the country have started to offer leadership programs that span several months of field trips, speakers, and hands-on activities designed to have you know your community inside out. The ones that I'm familiar with are quite excellent, and they provide unparalleled opportunities for expanding your own intelligence and opening doors to networking on a higher level. These leadership programs can be somewhat costly, but no more so than a really good one- or two-day business seminar. One that I participated in several years ago

had me climbing a sixty-foot "alpine tower" as part of a team-building activity. It was scary, but to say it was motivational is an understatement. If you are a leader-in-training, this type of program is something that you must do.

22. If you are a Chamber member, bring your non-member friends and associates to Chamber functions once in a while. They can network with, and for you. They may know people that you don't know at events and feel very comfortable making introductions. It also helps them to improve their *ideal networks*.

23. If you have a product or service that would appeal to a certain segment of the population, ask your Chamber staff to help you find a way to reach that niche market. For instance, many Chambers also operate a visitor center, so perhaps you could provide a coupon or freebie to be handed out to visitors. If you live in an area where there are summer rentals, you'll discover that many property management agencies look for appropriate items to put into goodie bags for vacationers. Whoever is producing a golf tourney in your area is looking for goodie bag items as well. Your Chamber staff can likely direct you to these outlets. Brainstorming niche-marketing ideas with members should be a welcome activity at any Chamber of Commerce.

24. Leads Groups are fairly common among Chambers, but I've found that some are lacking in organization, are too small, their meetings are held too early or late, or they involve too many of the same type of people. If there isn't one that appeals to you, ask your Chamber if you can start one, with their support. Let them promote it for you and help you set up the location. Be sure to do a good job organizing the group and keep it fresh, with new faces, new ideas, and lots of opportunity to share openly and individually. Remember, your Chamber is a membership-based nonprofit organization with a mission to support businesses. Use their services.

25. Your Chamber is uniquely positioned in a leadership role, with a responsibility to tackle issues and critical situations that may impact the local economy. Chambers often organize highly

visible projects to mobilize their members to vote a certain way on a bond referendum, attend public hearings having to do with tax hikes, or fight closings of major government-supported organizations. If you live in an area that has a military base or tourist attraction, there will always be a bandwagon on which to jump. Becoming part of something significant is good for your spirit. You get the chance to do something for the common good, for the welfare of your community or your state, under the umbrella of the Chamber, with fellow members at your side.

The network you'll be exposed to in this arena is pretty cool. The people you meet will be soldiers for a cause and are, for the most part, participating because they feel deeply. Look for that feeling inside yourself and step up to the plate. Offer to work the polls for that bond referendum on Election Day, attend the public hearings when numbers count, write that letter to your legislator, or sign and forward that petition. Sometimes we can get trapped in our own busy world of ideas and plans, drifting away from the knowledge that others also have meaningful goals and work to do. Even if what we're working on could bring food to the hungry, it's important that we sometimes see beyond our own life's work and ask what we can do to serve the greater good of our community of business owners and entrepreneurs. The Chamber of Commerce is a relevant place to ask that question.

26. When attending grand openings, ribbon cuttings, or other "hosted" events, bring a small gift of appreciation for the host. You could present a plant, candle, pound cake, or box of note cards. Include one of your business cards and a product or service offer, if appropriate. Since the event host is a new business owner, drop by a week after the event to see how things are going and offer help in making connections that may be useful.

27. Should you wish to expand your network beyond the boundaries of your own community, express interest to the Chamber staff about becoming an appointed representative on regional or state committees. Chambers generally are allowed committee or board positions within organizations that deal with major issues on a

broader scale, such as: tourism development councils, economic development boards, education committees, and regional industrial commissions. If this is of interest to you and you are a new Chamber member, get active as quickly as possible. Your track record in attending and chairing functions builds you the credibility needed to secure an appointment at this level. It is worth it, because your network of valuable resources will grow in numbers and also in capabilities.

28. Should you send out press releases about your business, be sure to e-mail or fax a release to the Chamber office. News about teaching a class, receiving a promotion or an award, adding a new service, hosting an event, or launching a new Web site could be printed in their newsletter. Keep them informed.

29. Your Chamber of Commerce may have marketing research that you need to write a business plan, make a location decision, or create a sales campaign. The Chamber staff should be able to provide local traffic counts, city populations, high school and college populations, property tax rates, business and industry breakdowns, and licensing information. If you are starting a nonprofit organization or working on a community project, the Chamber could have grant information and a contact list for every city, state, and congressional legislator. Information may be available on the Chamber's Web site, but ask if you don't see exactly what you need. The Chamber has extensive files, or could probably help you otherwise in your search.

30. Look for those who interest you within the Chamber's membership and connect with them. Besides business owners, you'll find individuals, government officials, festival coordinators, and even other civic and business organizations (where the actual contact point could be a chairperson or executive). Learn about what their organizations offer; they can introduce you to other business leaders. Ask for an invitation to attend one of their meetings. Their Chamber member representative will introduce you at their meeting, and your business network will flourish. Be on the lookout for potential mentors, because this is the kind of scenario where advising and teaching relationships flourish.

31. The best way to secure a return on your membership investment with the Chamber of Commerce is to make the Chamber your customer. It is important to note that most Chambers of Commerce prefer to conduct business only with Chamber members. If there are several competing Chamber businesses, the Chamber will most likely open to bid or solicit estimates for what they need. However, if you are the only one in your field, or if you offer something unique, you're going to get their business. Bottom line: Joining the Chamber of Commerce doesn't just mean that you are opening up opportunities to do business *through* them; you can also do business *with* them.

There are plenty of opportunities to make money with the Chamber of Commerce, if a businesswoman is savvy and creative, but being informed is key. The Chamber of Commerce is a business unto itself, with a facility, staff, Board of Directors, and several committees that are constantly producing events, programs, and generating advertising and marketing opportunities. As a nonprofit organization, the Chamber has special operational requirements that differ from a regular business. Knowing those requirements and understanding how the Chamber operates will help you, as a business owner, to determine the best way to package or tailor your products and services to meet the Chamber's specific needs.

As a Chamber member, you should have access to the Chamber's bylaws and the annual report. Read them to learn their budget breakdown, when their fiscal year ends, and when they do their budget planning. If you want to submit a proposal for services, you'll want to do it before they start that planning. If you know what their annual events are and when they are held, you have an opportunity to plan ahead for what products or services might be appropriate. The annual report will probably inform you of what plans they have for the next year. Knowing if they are planning to expand their staff, start construction on a new building or redesign their office, plan a huge seminar, investigate benefits for the staff, hire a public relations consultant, or add on a cleaning service might be of interest to you.

Most Chambers conduct an annual financial audit, which should be noted in the bylaws, so if you are a CPA, that's great intelligence. Don't be put off if you are aware that the Chamber is utilizing the same CPA that they have had for years. The most consistent thing about a nonprofit organization is its tendency to be inconsistent. Change will come—most often with a change in leadership, but change can also be facilitated when a "good deal" is on the table. When you know what their current "deal" is (perhaps by checking their annual report and budget or talking with them regularly), then you can create a better one.

Many Chambers shop for liability insurance for their special events and also for their Board of Directors, and if your Chamber does, that will likely be included in their bylaws or noted in the budget. If you are an architect or interior designer, knowing that they want to break ground in a year or two on a new building could be noteworthy. If the words "building fund" show up in the budget or annual report, there's your clue. Every Chamber gives out awards, so knowing when they plan their annual gala and when their individual committees hold award luncheons would be invaluable information if you are an engraver, printer, artist, framer, photographer, calligrapher or florist.

If you are still wondering if what you do could be useful to a Chamber of Commerce, here are some of the services Chambers use frequently: Web site design and management, office cleaning, live plant maintenance, venue and event planning and/or management, financial advice and services, music, catering, printing, advertising, temporary personnel, drinking water deliveries, lobbyist services, image consulting, legal services, seminar and workshop facilitation, bus transportation, screen printing, office supplies, insurance, vending, lobby brochure and kiosk services, membership management software, systems products and installation, and computer training, repairs, and maintenance.

Even if you don't see your business on this list, don't necessarily assume the Chamber cannot utilize your product, service, skill or talent. This is where your creativity will serve you. If your Chamber cannot afford your monthly Web site

management fees, propose a contract to train their staff to handle the management in-house. If you are an event planner or travel agent, come up with a "fund-raiser trip" like a cruise package where you'd donate your free rooms and a percentage to the Chamber. You could also create a package of services for major events that would free up the staff or handle details that are beyond their skills. Many Chambers, like a good many nonprofit organizations, aren't offering their staff comprehensive benefits because of cost. If your business involves financial investments or insurance, see what you can come up with as a package and pitch it to someone on the Board of Directors. To this day, I still do business with an investment and insurance advisor who offered me an affordable insurance plan when I was a Chamber Executive Director.

If you are a baker, find out when the Chamber does its regular breakfast gatherings (or propose that they do, should breakfasts not be a part of their monthly calendar) and work a deal for a pastry tray and coffee for those events, a month or so at a time. I recall when a French bakery was preparing to open next door to the Chamber office. The owners brought fabulous pastries to the staff every day for about three weeks to test their goods. We all became so addicted to the fresh, warm, chocolate croissants, and baguettes that when the bakery finally opened for business, we couldn't get there fast enough. When they added some tables and chairs to their space, our addiction became their opportunity to negotiate a deal to host some small member gatherings.

Every Chamber of Commerce is in need of something. Find out what it is because adding the local Chamber of Commerce to your list of clients could be an important boost to your business. If you can find a way to do business with the Chamber, get a testimonial from them and add that to your Web site or printed marketing materials. In addition to getting a major return on your membership, you will also enhance your business standing in the community, and could expand your customer base with Chamber members who have heard about your success. We all know that success breeds success.

Chapter 10

THE CARE AND FEEDING OF YOUR IDEAL NETWORK

By now, you are on your way to tremendous success, with the best marketing tool and business team you could have imagined. What makes your *ideal network* really special is that what you've created is perfect for you—a custom fit for your needs, your projects, and your dreams. You are the envy of all of your friends! Perhaps the nonbelievers (you know who I'm talking about) are just a bit unnerved at your ability to turn things to gold. Aha! Little do they know that you are not only going to cruise right past "Go," you are going to make big things happen, with the help of your new "staff."

This *ideal network* is one of the best things you've got going, so you must protect and maintain it. That old saying, "use it or lose it," applies here. Number one on your "to do" list is to utilize your contacts with some regularity. You don't have to wait until you are launching a marketing project to ask for help. You might make a chart, as shown in Chapter 3, about developing a habit of making connections frequently. Ask for suggestions on reorganizing a home office, or for a recommendation on what coffeepot to buy, or about how much to tip servers while on vacation. Don't conjure up reasons to bug people, but do ask for real advice from your network members; it will be of value to you, and it will also be a means of giving attention and compliments to them.

With that thought in mind, here are some routine "admin" things you need to do:

- Once a week: E-mail or call three contacts to check in and see what's new. Share what you've been doing. This inevitably results in at least one lunch connection for me. Many times, opportunities of mutual benefit are discovered.

 Note: I've designated Mondays as my "admin" days, so that's when I do my e-mail connecting.

- Once a week: Pick one of your connectors, mentors, or media contacts and set up an in-person meeting, such as lunch or coffee, as a casual "catching up" meeting. Take a small pad of paper and a pen with you in case your contact shares something you'd like to remember later.

- All month: As you come across newspaper articles that spotlight any of your network contacts, cut out the articles and send them with a personal note. Pass along pertinent information to those in your network who would appreciate knowing about opportunities or changes within the community. Don't just set aside the chance to connect because you get busy or assume people already know the same information you do. The fact that you took the time to share something that could benefit them will be greatly appreciated.

- Once a month: Update your *ideal network* with new contacts, make changes in addresses, and reorganize, if necessary. If you are using a Rolodex® organizer, staple any business cards you've collected to the back so that the fronts of all of your entries look similar. You don't want distractions like logos and photos jumping out at you each time you are reviewing your *ideal network* for contacts.

- During the month: I toss notes on potential new network members and updates on current members into a basket. On the day I do my monthly invoicing to clients, I review the notes to see if any action needs to be taken. This is also a good time to do a little value-added networking. Include a magazine article you think your client would enjoy, add a coupon to try a new service, or a couple of your business cards, with a freebie for a referral. This is an effective

practice for showing appreciation to your clients. I was hired some time ago by a client to help plan and produce a major business event. I worked like a madwoman for two months, and when the event was over, I invoiced him for the hours worked. I noted on the invoice that I was contributing the hours worked on the actual day of the event as a thank-you for his business. That day was, by far, the longest and hardest day of work I've had in a while, but I gave it as a gift. My client mentioned his surprise and appreciation the next time we met, and he has continued to bring me business ever since. Upon completion of another project, I included with the invoice a brief "stat" report for a client that loves facts and figures. This unsolicited report revealed the success of the project in numbers—something he appreciated and, no doubt, saved.

Though these tasks are fairly simple, should you need a mind-jog to help you in taking care of your *ideal network*, visit www.theidealnetworksystem.com for a downloadable monthly networking calendar. The calendar includes the regular administrative tasks mentioned here, as well as a monthly "challenge" designed to stretch your networking skills.

Other than what you do regularly as a part of your networking routine, here are nine additional ideas for keeping your network ideal:

1. Ask for a stack of business cards and make referrals for your network members.

2. Share your *ideal network*. If someone from your network is looking for a Supporter, Mentor, Connector or Decision Maker, share if you feel comfortable doing so.

3. Invite members of your network to participate in your projects. Review paragraphs 1–5 in Chapter 3 first, to prepare yourself for taking on collaborators. As well as asking them for advice, you can also ask your network members to help you organize an event; contribute to a grant, article, or booklet you are writing; coordinate a program; or serve on a committee with you. Allowing

members of your network to utilize their talents and intelligence by participating in projects with you expands their opportunities and shows how much you value them. You may be able to handle your project alone, but inviting network members to participate in what you are doing creates a stronger bond. Even if they cannot participate, they will not forget the offer.

4. Again, I'll mention the importance of listening when you are in direct communication with a member of your network. You need to know as much as possible about these resources, or you could be limiting yourself and them, too. You can use the sixty-forty rule: Listen sixty percent of the time, and speak only forty percent of the time (less, if you are connected to an active talker). Think of listening minutes as "brownie points." This can be difficult if you are an entrepreneur, but your contacts will appreciate the attention.

5. Be available to your current network and be timely in your responses.

6. Keep your contact information current with your network members. I don't recommend changing cell phone numbers and e-mail addresses too often, because those who have to update your information constantly will eventually lose interest.

7. Offer endorsements and testimonials where you feel it would be appropriate.

8. Be of service to entrepreneurs. You know how much you appreciate support from other business professionals. Provide advice whenever you can and congratulate entrepreneurs when they have successes. Assist them in growing their networks. You can start by becoming a member of their *ideal network*. You'll grow as they do.

9. Stay aware and interested in the members of your network on a personal level. Know who is getting married, having babies, changing jobs, suffering a loss, or enduring challenges. You don't have to be best friends with someone

to offer encouragement or express concern. Unexpected cards or notes are always appreciated.

As you consider what you want to do for your network to keep it strong, consider also what your network "needs" from you. Your network needs to know you—they need your story. Your story is more than what you do for a living. In fact, what you do to earn a living may actually have little to do with who you are in your soul. You are a bundle of talents and passions, and how you go about revealing those talents and passions are important to your story. People in your network who know this about you will be of more support and service. Come up with a couple of sentences that fit. Here's my story: I'm a connector who utilizes media vehicles to connect with people. I write, act, and produce for publication, and for radio. As a creative entrepreneur, I live for new projects and love to help people in pursuit of their dreams.

You may not verbalize your story exactly the way you would write it down, but as long as you are clear about who you are, when the opportunity presents itself, you'll be able to convey your story with ease.

Along with your story, your network also needs your image. I'm a very visual person, meaning that for me, seeing is knowing. When I know what a person looks like, the connection feels more complete. The more senses you can allow people to use to help remember you, the better, so I recommend providing your photo image on your business card, on a Web site, or in your other marketing materials. Get a professional photographer to take the photo, so that it is crisp and shows you in the best light. You'll get tons of marketing mileage out of a great photo, but be sure to keep it current. If you already have a photo and want to use it to create a brochure or other marketing piece, check out www.hp.com. Hewlett-Packard, which ranks #1 globally for sales in color printers, and whose Web sites have ranked among the top ten best sites for support, offers lots of information, online courses, and free templates and downloads to help you make good use of that photo.

There's one more thing that your network needs: reasons to connect with you. You know why you wish to make contact with your network members, but giving them reasons for wanting to

make or keep contact with you is a bit different. What do you have that others may need or want? Do you have specific information, news, opportunities, an acquisition, or an interesting project you are working on? Have you learned a rare skill, made a fabulous contact they'd like to know about, or is there something you'd like to offer or share? If you are a connector or a problem solver, that could be reason enough for your network members to keep your phone number on speed dial, but if you are exceptionally good at giving praise, that is your best assurance for network loyalty.

As a means of preventing you from making mistakes in maintaining your network, I will list here a few pet peeves I have regarding connections. You'll find that some of them relate to ideas offered earlier, thereby strengthening the point. I'm certainly not perfect, so if you "discover yourself" in any of these pet peeves, know that I'm not trying to make you feel bad. My aim is to show how these situations can thwart your ability to keep your networking efforts healthy and your communications positive.

Pet Peeve #1: People who don't check their e-mail regularly

I think I've heard every excuse over the years: "I only check my e-mail on weekends. I'm too busy during the week; my secretary checks my e-mail—I don't really get into that stuff; I get too many forwards or so much spam that it takes a long time to download my e-mails; I only use my e-mail when I want to contact someone; I'd rather talk to people on the phone than deal with e-mail."

My thinking is this: You'd never dream of owning a Post Office box and then not checking it daily. Once you are linked in some way to the Internet, you allow all kinds of opportunities to come your way. You shouldn't ignore any means of communication where you have "opened the door." E-mail makes it so easy for people to connect that it is a preferred method for a large segment of our population, particularly businesses. More than sixty million American adults use the Internet and e-mail as a way to conduct daily business, stay socially connected, and find help in making important decisions. Bottom line—check your e-mail every day, several times a day if you can. It is an important way for you to be more responsive to your current and future network.

Pet Peeve #2: People who answer the phone, but shouldn't

You are communicating to someone the moment you answer the phone. In mere seconds, you've allowed a potential client to see exactly who you are, and that may be all it takes to convince them not to do business with you. Be aware of your state of mind because it is projected. I can tell when I've reached someone who isn't prepared to speak with callers. I'm made to feel as though I'm a terrorist calling from a foreign country. The "hello" I get sounds more like a question. There is hesitancy or suspicion in the tone of the person I've reached, and invariably, I must repeat and spell my name at least three times. If I'm leaving a message for someone else, I'm registering serious doubt at this point as to whether or not that person will get the message. We all have a difficult day once in a while, but allowing callers to leave a message to be returned later might be a better choice.

Pet Peeve #3: People who speak negatively about clients with other clients

Imagine arriving for your first appointment with a new beauty salon and finding no receptionist. You sit quietly, reading a magazine, waiting until your hairdresser calls you to her chair. You wait and wait. You're getting a bit unnerved. Then, from behind a partition, you hear a hairdresser speaking openly in a frustrated tone, "I don't know where my next client is…how rude…if she shows up, I just may have to tell her…." Yes, I kept the appointment, but I never returned.

You should never talk negatively about your clients in public or with other clients. I'm aware that we're all only human and we're guilty of gossip on occasion, but gossiping regularly will eat away at any positive networking you try to do and will cost you business in the long run.

Pet Peeve #4: People who don't keep their Web sites current and accurately updated

During a two-and-a-half-year period, I was paid by a client to conduct over 1,000 hours of research on the Internet. I checked out everything from wineries to retirement developments, and

community and tourism Web sites for almost every major resort in the United States and several around the globe. My job included a thorough review of all information available on the assigned subjects; therefore, I often searched a Web site for a contact where I could request hard-copy material. Here's my assessment: After reviewing thousands and thousands of Web sites, I've determined that a great many people put up sites and then leave them alone or even forget about them. I found a lot of sites with "dead" links, incorrect e-mail addresses or phone numbers, and absolutely no means of contact—no phone numbers, addresses, or e-mail addresses. It's hard to imagine that businesses or attractions that are attempting to solicit customers would overlook such important information. My take on this is that we know our own information and ourselves so well that we forget the obvious. We also tend to set aside that which we've already created. It's done—it's complete, and now we can go on to other projects. In actuality, getting that Web site finally up and operating only signals the beginning. You've just started the party.

Recently, while helping a company design a marketing piece, I checked out several links on their main Web site, thinking I could obtain useful information. In less than fifteen minutes, I discovered that one Web site link took you to an incorrect site, and another site was struggling to load to the point that I had to abandon connection twice. Not long ago, I e-mailed a local organization from its Web site for more information. The only e-mail address offered was on the sponsorship page, and it was incorrect. The contact person for the organization was unaware of the problem until I informed her.

I once e-mailed a client from her Web site. When I didn't get a response, I called to inform her that she might have a problem with that address. She discovered that the e-mail address from the site was attached to an e-mail address she had discontinued three years earlier. Imagine her dismay at understanding that three years of e-mails from potential customers visiting her Web site simply vanished. I find incorrect e-mail addresses on Web sites so frequently that I'm calling it an epidemic. A Web site is like having a virtual "Open" sign turned on all of the time. It's an international branch of your business that requires the boss to check in every now and again to make sure this avenue of communication is operational.

These are some of my pet peeves when it comes to networking and keeping connections strong, but there is another matter I wish to bring up for your consideration before we conclude this chapter on caring for your network. It is about returning phone calls. Most of us have "Caller ID," which affords us the opportunity to choose whether or not to answer a call at that moment. If we choose not to answer the call at that time, then we have the choice of whether or not we actually return the call at all.

I work from home, and a lot of my work revolves around research and writing. If I were to answer or return every single call that I receive, that is all I would do from morning till night. The unscheduled interruptions would play havoc with the focus I require to complete projects. I'm generally very responsive to my network members and try to be responsive to others who make contact. As a connector who interacts with people regularly, I'm aware, though, that some people call because they need to be heard, even though what they wish to discuss at length will bear no fruit for anyone concerned. One might compare these calls to junk mail or "spam." I believe that there must be an ethical and compassionate way to manage people who seek connection mostly for the sake of getting attention from people that they know are good at giving attention.

While considering this issue of choice of response, I was gifted with a couple of scenarios that gave me reason to develop a sort of personal policy. Twice in a month I ran into a woman who had recently left her previous job. She had actually walked out after a brewing frustration with the owner of the company peaked. After the event, she placed phone calls to customers of that business to defend her actions. She left a message on my answering machine one evening that let me know that her intention was to give me the "real" story. Now, I'm merely an acquaintance of hers and a customer, and I didn't feel it proper or imperative that we have this discussion, so accordingly, I did not return the call. Of course, each time I saw the woman afterward, she brought up the fact that I had not returned her call. Should I have? Hmmn.

On another occasion, I found myself returning phone calls to a gentleman who was seeking me out simply to vent about his business situation—a situation he had already decided how to

correct. He had made the best choice he could see for himself, yet he seemed more interested in his status as a "victim" than in moving ahead. I like being able to support people, but I had to wonder if it was a good choice for me to have returned those calls. When people are overinvested in their own upset, it seems like they seek every means by which they can exorcise those feelings, with no resulting benefit to anyone. I realize that some people bring about closure in this way, and I want to be a good listener for people whom I know personally need that from me. But, I don't think anyone wants to entertain at length someone's rude and angry commentary. It's negative stuff, and negativity only brews up more of the same, often preventing productivity.

These situations, and others where my "connector" nature led me into predicaments with communication, caused me to institute my own policies regarding choosing to return phone calls. I'm sharing some of those policies as suggestions to help you in developing your own. In those situations where you suspect you need to practice a choice in returning a call:

- Use e-mail as the primary source of communication, particularly where a contact requires lots of connection. E-mail allows for greater control in terms of timing and limiting responses. Let callers know that this is the preferred method of communication. Once someone is converted to e-mail communication, don't respond to his or her phone calls unless it is necessary. Continue responding via e-mail.

- If you believe that it was inappropriate for you to receive the call, then it would be inappropriate for you to return the call.

- If you feel a conversation is actually necessary, schedule it at a time when you know there will be a natural cut-off, such as near lunchtime or closing time.

- If someone is calling to discuss a subject in which you don't wish to participate because of negative content, that call should not be returned. Honoring and protecting your energies, time, and integrity are important. If you happen to see that caller and she mentions your non-response, ask if

there was something she needed from you. This will separate those who were seeking action or advice from those who really just wanted to bend your ear for a while. Should she truly need something from you, you can either have her e-mail you with information or tell her politely that the subject isn't something you'd like to get involved with right now.

Aside from practicing choice when returning calls to people you feel might zap too much energy from you, you do need to be responsive to members of your *ideal network*. If they are in your network, they deserve your unconditional attention. Do your best to elevate these connections to a level of significance. Even if you cannot do justice to a call or e-mail right away, try to inform them that you will respond as soon as you are available. Do what you would appreciate someone doing for you.

The whole idea around maintaining your network comes down to improving the quality of your connections. It's an issue of quality over quantity. The benefits to you and your network will make every second of effort worthwhile.

Chapter 11

THE ONE BIG THING THAT'S CRUCIAL TO YOUR SUCCESS

You can have dozens of names in your address book, tons of great ideas for your business, even money and resources, but if you don't have excellent follow-through skills, you'll never create success that breeds continued success. Follow-through is putting action to thought, and if you are really good at it, you not only have opened up opportunities for yourself, you've done it for others. This is a skill that isn't exclusive to business—it's a life skill.

Meet Keri

Keri is a smart, vivacious woman in her early thirties. During the day, she attends nursing school at the local community college and runs the numerous errands associated with being a single mother of three children. Most nights, you'll find her tending bar at a neighborhood restaurant, earning those extra bucks she needs to manage a household and go to school.

Keri asked me one day if I knew of any scholarship opportunities for women her age. She had already earned her RN degree and wanted to continue her university education to become a midwife. I knew of one resource that might be a possibility for Keri, if she fit certain criteria, but even then, the process would be challenging. I told her I'd make a connection and see what happened.

Within twenty-four hours, I e-mailed the person from my *ideal network* who serves on the committee for the scholarship I had in

mind. Almost immediately, I received a response indicating that my contact had already left a message for Keri to make an appointment. Now it was up to Keri to follow through. Busy as she was, and uncertain about the process, I wasn't sure if Keri would set the appointment and be willing to discuss the issues necessary to determine her candidacy for the scholarship.

It was weeks before I ran into Keri again, but she was quick to tell me how life changing this scholarship could be for her. With tears in her eyes, Keri explained that she met with the contact person, who actually offered to sponsor her application for the scholarship. As a recipient, not only would Keri's entire educational expenses be paid, but also her rent, groceries, gas, and utilities while she's attending school and even additional expenses, such as car repairs, if it interfered with her ability to attend school. Following a brief moment of silence upon the conclusion of her explanation, Keri and I both said simultaneously, "Oh…my…God!"

Almost three frustrating months of waiting passed before Keri was notified of her status. Her face was so lit with excitement that I knew right away. The words burst from her—"I got it, Miss Mary…I got it!"

I'm so grateful that I made a note about calling my resource person after Keri and I first spoke. As attentive as I try to be, details can often escape from memory. Not having followed through on this would have been a major mistake. And, had Keri not followed through—well, I'm sure she wouldn't even want to think about that.

I am conscientious about making follow-through a priority in my life. When I make promises, I need to keep them to maintain my integrity. However, sometimes follow-through does not come naturally for many of us. We must be diligent, especially when it involves a promise that is going to affect someone else's life.

While we might talk up our significant goals and projects, when it comes to actually following through on connections that people make for us, or tasks that will get us closer to our desires, sometimes that isn't easy. It's like we take a step into harsh reality from fantasy when we realize just how daunting it is to commit to taking action that we know could change our lives. These life-changing situations are what I call "big stuff."

Hamilton's Story

Hamilton Nobles is a young man who recently earned his real estate license. Not long before he attained the license, I mentioned to him that he should talk to a real estate professional that we both knew. This person owned a top-selling agency and might be able to find a way for Hamilton to affiliate with their office, when he was ready. It seemed to be a great situation for both parties—providing Hamilton with experienced mentors in a top notch agency, and providing that agency with an energetic, hardworking new talent.

Hamilton was busy—working at a night job, while completing his real estate studies during the day. Meanwhile, I spoke to the real estate professional on Hamilton's behalf. She agreed to meet, and suggested that Hamilton call her for an appointment. But Hamilton chose to wait to make that appointment. His reasoning for the delay may sound familiar to those of you with a past that you fear could haunt you in the present. Hamilton's history includes some costly mistakes that relate directly to a time in his life when alcohol trumped good sense.

What makes Hamilton's story especially interesting is that, although he might hesitate occasionally when he is confronted with certain choices, he has already followed through with the biggest choice of his life—the choice to save his life.

Hamilton has remained sober for close to four years. The action to follow through on getting sober had to be a tough one, particularly since it is ongoing, which shows his personal strength and ability to adapt. That's how I knew he would eventually move past his initial holding pattern. When he did call and meet with the real estate contact, she signed him on with her agency.

The story continues. Now connected with a successful real estate firm, Hamilton commenced creating his client base. I advised him to try conducting his own "mini e-mail campaign" (mentioned in Chapter 1) to generate some leads. His early results from following through on that action included access to the address book of an elected official, and a phone call from a business owner who will provide him with other connections. Hamilton seems to be on his way to building his new real estate business, but had his

initial hesitancy expanded into rock-solid procrastination, this story would have had a far different ending.

No matter the reason for our hesitations, they are usually founded in fear. The hoops we must jump through when changing life around to suit a new career path or a new business endeavor can keep fear levels high enough to stop us from following through. Hesitancy is the cousin of procrastination. Neither are really good friends if you have big plans.

I'm not saying that you shouldn't think through your decisions carefully, but when desirable opportunities surface, you have to muster up the follow-through skills even to commence exploration. Often, exploration alone will provide you with the exact information you need to make a good decision or prepare for a positive transition. Indecision is just an invitation for procrastination, because if you know what action you need to take but don't do it, things can get seriously out of control.

Chris' Situation

Years ago, Chris founded an organization for troubled youth that required her to find people who would help raise funds and set policy. The decision makers proved to be better at setting policy than raising funds; this was not exactly the support system Chris had wanted. Their decisions cost Chris thousands of dollars in lost income, which resulted in her constantly worrying about money and being forced to work a second job at a discount store. This stress in turn produced health-related issues that she will have for the rest of her life.

Why did Chris tolerate this kind of situation? She had over invested, committing way more than her time, energy, and hard work; very simply, she had given her heart to the organization. Although that is absolutely understandable, regrettably it kept her from taking action she knew was right.

While Chris was busy trying to figure out finances, her decision-makers were unwittingly orchestrating the organization's dissolution. When the end finally came, that was probably a relief, but I'm sure the pain and grief lingered with Chris for a long time.

The inevitable downfall was not a surprise; Chris could see it coming but could not bring herself to follow through on the one

action that would get her out of pain and on with her life. Procrastination had smothered her thin hope that things would improve and magnified her fear of letting go. She certainly paid the price but eventually moved on.

If you think this would never happen to you, think again. In your lifetime, you will love something or someone so much that you'll allow all kinds of damage before saying "stop." Maybe it has already happened. But love isn't the only reason we allow pain.

I know two people who are employed at jobs they absolutely hate. One has been at her job for just over three years and the other for almost ten years. Their discontent ranges from lack of decent pay, benefits, and appreciation to abusive coworkers and an inability to move up in the company. Both have vacillated between knowing they desperately need to find a new job and a state we'll call "teeth-gritting toleration." Somehow, they continue to hang on.

When we are willing to get comfortable in "the known" rather than opt for the fearful "unknown," we refuse to take necessary action. But here's the deal—if a bad situation has gone on for a while and you know there is an action that could relieve your pain, then you've already made your choice. You do have the option to take intelligent action on that choice. Taking that action will allow new opportunity to come forward; otherwise, there is no reason or space created for it to emerge. Good follow-through not only means taking action to create positive situations; it means taking action to prevent negative situations.

These unhappy employees practice good follow-through skills when handling the daily details of their jobs and lives. But they become stuck when a painful issue presents a need for immediate, decisive action. Neither employee, however, should be considered a habitual procrastinator. That label applies to people who have ongoing problems in managing multiple situations.

In almost every case where inability to follow through or procrastination is a regular occurrence, you'll find time-management issues. Everyone experiences procrastination once in a while, but you simply cannot live constantly in that state and expect to have the kind of success that you want. Further, your sanity is at risk because of the frustrations of constantly playing "catch-up" with work, putting off decisions or second-guessing yourself, and allowing opportunities to

pass you by. But the most significant problem here is that people who know that you procrastinate will avoid working with you, believing that you are lazy and without priorities. You'll feel like you are in a perpetual state of overwhelm.

Josh, the Freelance Writer

There's a gentleman I have observed (we'll call him Josh) who wanted to start his own freelance writing business for years. He finally got the opportunity when he was laid off. Creative and talented, Josh is also very friendly and down-to-earth. He started taking on customers who needed marketing copy written or articles ghostwritten. Excited by his success at securing customers, Josh set about tackling the seemingly endless list of writing assignments. And that's when the problems began.

As with any work that relies heavily on your own creativity, timing issues can crop up. Writing is not like filling orders for products. You are the producer of the product, but since life doesn't wait for you to be inspired or to puzzle out answers, you can find yourself up against a brick wall in a hurry. In Josh's case, he and that brick wall met up in a matter of weeks. He found himself giving excuses to customers about why he had missed deadlines or was unavailable for a phone conference. With only a handful of customers to service, Josh was already seriously overwhelmed.

In order to get relief from feeling overwhelmed, Josh needed to implement some means of time management, but that, too, proved to be struggle. He concluded that his growing frustrations were a result of working too hard at trying to "create" for such a diverse group of customers. He was convinced he needed more personal time. If he could reduce stress, then he believed he could become more productive.

Interesting assessment, don't you think? His solution was to designate more days off and spend time exploring techniques and tools to help him manage his different writing assignments. He chose not to take on new customers with the idea that he could do a better job if he had fewer people to serve.

Not surprisingly, Josh eventually lost all but two customers, but actually he lost so much more than that. He lost his drive to succeed, his momentum, his credibility, and some potential

referrals. Subsequently, his entrepreneurial spirit disappeared, and Josh decided that self-employment was not his "thing."

Josh's story is a common one. If you aren't going to make it in business, you will often find out earlier rather than later. Josh barely got off the ground with his business before he was smacked with reality. You have to be ready for the demands of business, and you have to be able to follow through. It does absolutely no good to be talented, intelligent, and friendly if you are going to allow procrastination to take over. Josh admits to learning something about himself with this experience, but the dream of owning his own business is currently taking a back seat to a job hunt. Hopefully, what he learned will help him in whatever new job he finds.

Serious procrastination will wreak havoc on you and your business. I know a consultant who lost a job worth a couple thousand dollars, and he lost the client along with the job. That client, and her referrals, would have been worth considerably more than two thousand dollars over the years. Worse than that, he lost future referrals from the person who had made the initial referral. His excuses for not producing had piled up longer than seemed reasonable to the client, and that effectively killed the deal.

As it turned out, the consultant has a reputation for procrastination with his clients, as the current client found out when she started asking around town about him after she had difficulties reaching him.

Unfortunately, I too know about the consultant's situation, because people talk. The unhappy current client talked, and the unhappy referrer talked. The new consultant that the client hires is going to hear all about this, and you can bet that the person who made the referral is going to share this story with anyone who asks her to recommend the same service in the future. It only takes one episode like this to cause problems for your business. When you develop a reputation based solely on procrastination, you're really heading for bad times.

I've talked so much about what can happen when you lack follow-through skills to scare you a little. I want your *ideal network* to have full benefit from you. And, I want you to make the most of the potential that lies in your connections.

Most business owners know the value of taking actions, but usually we think of action in terms of small details. And, while I realize that even small actions are important to building and maintaining a thriving business and lifestyle, it's the "big stuff" that I think needs the most attention.

Kay's Quest

Delena Kay Flakes is an extraordinary woman of faith, with an ability and desire to connect with people who are considered outcasts. In her job within the Texas prison system, she interacts daily with some of the nation's most dangerous offenders. These are people, as she puts it, "who must now, because of a history of extremely bad choices, live a life of hopelessness." Kay has found her mission in life.

Kay has her doctorate in psychology and is one of a handful of prison professionals who were granted access to famed serial killer Henry Lee Lucas. From conversations with Lucas and many other prisoners over the years, Kay has developed a special insight into the mentality of people who cause their own rejection from society. That insight, along with her commitment to God, prompted her to take her message of hope and positive action to a national audience. Kay's intention is to provide people in halfway houses, prison release programs, or in various desperate situations, with the motivation and plan for creating a positive life.

When Kay and I met for our first client session in late 2006, she was following through on her goal of advancing her professional speaking career and attaining greater visibility. She had already published several books and had begun speaking locally. The title of her latest book seemed to sum up the theme of her new efforts: "Aggressive Pursuit." Packaging her marketing around that theme was the beginning step in creating a professional image that could expand her visibility.

Additionally, Kay updated her Web site, sent out requests for endorsements, and worked on producing the media kit that I suggested. She made mentoring connections, researched specific media vehicles, joined national organizations that we discussed, and sought involvement with appropriate local groups.

Here's an excerpt from a recent e-mail I received from Kay:

"Hello Mary,
I had a book signing at the library. They had a display using information from my media kit!! I got feedback from people who knew me and saw the display at the library—that was great! I have served as the Mistress of Ceremony for two different programs—a countywide audience—made some contacts after each one. I was asked to participate in a Victim Services Convention in Austin, Texas. I landed the radio interview in Killeen, Texas! It was great! I did record it, like you suggested. Also, I had a book signing at Hastings. They were so impressed with me that they wanted to keep copies of all my books on their shelves, and they used the media kit, once again, to make a display! I secured an interview with one of the local papers—this one is distributed throughout the county and surrounding areas. I was asked to supervise an endeavor sponsored by a nonprofit organization. The program is called "Act Out" and will target youth in our city. We will be working on entertainment skills and a final presentation that will take place after all of the workshops! I am moving right along!!!"

Don't you love her excitement? What I love just as much as her excitement is her determination to follow through on everything. Every connection is processed, and every action is yielding results. She's quickly making a name for herself, which means she'll be reaching her greater goal in no time. Kay is not only growing her own fantastic *ideal network*, she is going to be a wonderful *ideal network* member for those smart enough to include this "queen of follow-through."

The reason I wanted to use Kay's story to conclude this chapter on follow-through is because her "big stuff" is going to change people's lives. Beyond the benefits she receives that help her create a successful business, every single time that she follows through with a step toward her goal, she is getting closer to helping create success for someone else. You don't have to be a person with a mission to make a difference for others. The potential to bring good to another person is in already each of us, and can be hiding within our most important dreams and business goals. And, that is reason enough to follow through on your own "big stuff." I challenge you to make follow-through a daily priority—for yourself, for your network, and for those people who need your success to help them achieve their own. They're waiting.

Chapter 12

THE NEVER-FAIL CONNECTION

The never-fail connection is accessible twenty-four/seven, doesn't care how you are dressed or if you are dressed, supports you unconditionally, requires no money from you, and has every resource within its reach. It is the spiritual connection. This connection can sometimes be forgotten or unused, but tapping that spiritual support system, whatever your religion or personal belief, can help you in every aspect of your life, business included. I'm as guilty as anyone else for not consistently keeping a truly thriving connection, spiritually speaking, but I've learned that when I do, fantastic, unbelievable, outrageous opportunities happen. Want an example? I'll give you a few.

Some years ago, a waiter told me that he had put together a list of one hundred things he wanted to do before he died. I liked the idea, so I wrote my list in the journal where I keep all of my secrets, longings, and spiritual conversations. I ended up with 104 items on my list of things to do before I die, and one of them addressed my desire to get close to a tiger. I've always been in love with tigers, and apparently when I wrote about wanting to meet one in my journal, my heart palpitations signaled the planets to align. Not long after compiling this list, I was visiting my son at his college. I discovered that his girlfriend was planning to work at a wild animal refuge over the summer. She pulled up the organization's Web site on the computer to show me photos of the refuge. Beautiful furry faces were coming up on the screen—gorgeous orange and black tigers. I was in awe.

One week later, more than two hundred miles away in a tiny wine shop, I picked up a calendar with a picture of a tiger on the front. Incredibly, the calendar was produced by the organization whose Web site I had seen days earlier. I found my husband roaming through the shop and told him. A customer, overhearing my excitement, told me that the owner of the tiger kept an apartment just upstairs from the shop. It turned out that he was there that very weekend. I met the owner, and he kindly invited me to the refuge to meet his beautiful Bengal tiger in person. I did. Just inches from his face, on the other side of a chain link fence, I could feel "Tex's" breath against my skin. He "chuffed" an affectionate greeting, then purred contentedly as I felt the weight of his three-hundred-pound body push against mine. The experience was incredible, and caught on film for me to relive over and over again. What a memory! And given a few more months, it would not have happened. As it turned out, Tex's owner died within the year.

There are some things that you just know come from the ultimate connection.

The last week of July 1996, I wrote in my journal about wanting to meet a particular NBA player to see if I could talk him into endorsing a leadership program that I had co-founded for young athletes. Within a few days, a call came from a friend of mine who had been invited to a reception honoring this very individual. Her husband was unable to attend with her, and she wanted to know if I'd like to take his place. One week from the day I wrote about my desire to meet him, I was shaking the hand of NBA star Jerry Stackhouse—and obtaining his support for the program.

Convinced yet?

In my journal one New Year's Eve, I wrote about my interest in working on a film. I had been hosting and producing a local television show for a little while and was curious enough to want to have an experience within the film industry. My entry that day actually included these words: "I think it would be fun to work as an extra in a film." Within a few days, a friend in Wilmington, North Carolina, called to tell me that a director was in the area promoting the world premiere of his first film. His publicist was looking for media connections, and my friend thought he might be a good special guest for my show. I made arrangements and did the

entire show with that director. Afterwards, the cameraman and I had lunch on the lot of Screen Gems Studios. A casting director mistook us for extras and asked us if we could work the next day. Without blinking an eye, I responded, "Yes." It was a Muppet movie, so I arranged to take my daughter to work on the movie that day. I can't put into words what it was like walking onto a motion picture soundstage and catching a glimpse of my twelve-year-old daughter dancing alongside Miss Piggy. I was right—it was fun!

This last story ended up being more than just a once-in-a-lifetime experience. It eventually brought all kinds of opportunities to do business and create new and exciting connections. For starters, that young director I interviewed extended his personal invitation to me to attend the premiere and party as a VIP, and he also gave me media access to all of the stars. I ended up being the only media rep to get interviews of each star because the publicist brought them to me one by one.

I also remember asking Frank Capra, Jr., son of the famous film director of the same name, to guest on my local television show. Capra was the President of Screen Gems Studios in Wilmington, so we filmed the show on the lot. I took two middle-school children and a high school student with me to participate. It was an unforgettable afternoon, just like the one I spent with a special effects crew, some of whom had just completed working on the movie *The Patriot* with Mel Gibson. On that occasion, a wooded area was rigged to look like a smoky battlefield, as a stunt crew took on the roles of soldiers being blown up while engaged in war.

Along with several clients I acquired from the film and entertainment industry, I secured a paid position to run a local film festival. I found an agent and performed in motion picture, voice-over, Internet, and stage projects. All of this, and much more, I believe, stemmed from that very moment I wrote down what I wanted in my journal. I would never have had a clue as to what would unfold—but my spiritual connection did.

So, there you have it—your instant, no-hassle personal connection. You just need to find your best means of communicating your desires; then listen and become alert to new people and situations as they come into your life. My experience indicates that whatever it is that you put forward as a desire needs

to come from a place of passion, surety, and/or intense emotion. This seems to be the consistent factor in my engaging that connection that puts "coincidence" to work.

Deepak Chopra, in his book *The Spontaneous Fulfillment of Desire* (Harmony, 2003), explains the immense power that is gifted to the individual who is connected spiritually.

> "When you live your life with an appreciation of coincidences and their meanings, you connect with the underlying field of infinite possibilities. This is when the magic begins. This is a state I call synchrodestiny, in which it becomes possible to achieve the spontaneous fulfillment of our every desire. Synchrodestiny requires gaining access to a place deep within yourself, while at the same time awakening to the intricate dance of coincidences out in the physical world."

In 1993, the fictional book *The Celestine Prophecy* (Warner Books, 1993), fascinated readers worldwide and prompted a movement of exploring synchronicity and spiritual connections. So dynamic and affecting was this unique work that the "critical mass" that Redfield referred to in the book seemed to be actually occurring. The readership went counter to the typical profile for a spiritually based book. Bankers, community leaders, entrepreneurs, artists, young and old, male and female, were buying the book and perhaps the principles offered in it. One of those principles, or "insights," as designated by Redfield, is the Third Insight, A Matter of Energy.

> "We now experience that we live not in a material universe, but in a universe of dynamic energy. Everything extant is a field of sacred energy that we can sense and intuit. Moreover, we humans can project our energy by focusing our attention in the desired direction...where attention goes, energy flows...influencing other energy systems and increasing the pace of coincidences in our lives."

I'm a total believer in spiritual connection. I'll never forget the terrible fear and sense of rejection that surrounds divorce. When it was clear that my marriage had ended, I wondered how I'd manage as a single mother. I decided to move back to my hometown, three hours away from where I was living. With as much courage as I

could muster, I got my resume together and submitted an application for a job. I was called to an interview on Good Friday and was the last of four candidates being interviewed that day. As I waited at my parents' house for the outcome, I wondered out loud, "Even if by some miracle I did get the job, where would we live? I can't afford much."

Within an hour I had a phone call informing me that I had been hired as the new Executive Director for the Havelock Chamber of Commerce. This was more than a job; it was a community leadership position in my hometown. The same day I received the call about the position, my father, who was a local real estate agent, received a phone call from a tenant who was giving his two-weeks' notice to leave a house that my father owned. I had a home, and, not just any home, but one in a neighborhood alongside my two brothers and their families. I was going to be okay. You'll never convince me that my Higher Power didn't have a hand in this.

Tapping into your own unlimited source of energy isn't as hard as it may seem. Dr. Judith Orloff advocates developing a spiritual practice in her bestseller *Positive Energy* (Harmony, 2004). One of Orloff's suggestions to help create the spiritual connection is explained in the guideline entitled "Permit Yourself the Freedom to Explore What Moves You." She elaborates,

> "This is not necessarily what your friends and family follow or condone. You may link Spirit with God, Goddess, Allah, the Universe, or the wildness of a wind-blown sea. To begin exploring, get your hands on books, from William James' classic *The Variety of Religious Experience* to the Dalai Lama's *The Art of Happiness*. See what descriptions of spirit intuitively resonate and scrap the rest."

I've provided the quotes from the book above to demonstrate the plethora of choices out there to help you explore your own means of making a spiritual connection. Should you already have a wonderful connection in place, keep it that way. Otherwise, I encourage you to investigate and choose what feels right for you. As you do so, you'll notice that *ideal* contacts will seek you out, connections will practically fall in your lap, and you will experience surprising lightness and ease in your efforts.

Chapter 13

OTHER IDEAL INSTANT NETWORKING

Although I believe your source of spirit to be the Number One *Ideal Network* Staff member, the second best are your *ideal network* "connectors," who will almost always come through with information or resources. Networking is what they do naturally; for them, a room full of people is like a box of candy waiting to be sampled. Point them toward a crowd and they'll emerge with a pile of business cards or names on napkins. All you need to do is provide specifics about the kind of person or resource you need, and they'll likely come up with it, now or later. It's like a test they need to ace. You may have one or two connectors in your *ideal network*, but here is some advice about finding and using these contacts:

- Make sure that the people you think are connectors are "true" connectors instead of just wannabes. Salesmen, saleswomen, and people who have to network for a living are usually good connectors, as are community leaders and nonprofit executives, because they have to lobby and recruit members.

- Be clear about your need and provide a sense of urgency. Although it is unlike connectors to let go of a "bone," they will feel less inclined to get involved if you are too casual with the request.

So, if you need some fast help and you have several good connectors in your *ideal network*, I'd say they would be an excellent resource. Just don't rely on them too much because they'll become weary of you. After all, you have an entire network or "staff" waiting for your requests.

Since we're talking about putting your networking on a fast track, I want to offer you some additional resources that will promote your networking and marketing plans. Get your pen out and get ready to circle the ones you like:

1) Looking to transition into a career in a highly competitive profession? A really good recruitment firm specific to that profession can make things happen easier and faster for you. Ask around your network or use the Internet to locate appropriate recruiters. You'd be surprised how many different fields are represented. Just be sure to check out the companies you find, as well as their contractual terms.

2) Wear a nametag with your business name on it everywhere you go. Just dream up a name, make the tag or have it made, and wear it all day. A quick way to attract people interested in what you have to offer is to become a human billboard.

3) If you enjoy a tall, cold one or a glass of wine on occasion, you might check out "locals night" at the lounges of area restaurants. You'll likely find an interesting mix of business types, politicians, and community folk, all there to meet and mingle, find out the latest scoop, and enjoy some free goodies. Locals' night is a buffet in every sense of the word, so knock yourself out. And have a cup of coffee if alcohol isn't for you.

4) The IRS has dedicated a section of its Web site to self-employed persons, offering a listing of partnerships the IRS has created with businesses and organizations to provide information and resources. Tapping into their network of partners may save you money, frustration, and time. You can also include a link on your Web site to the IRS site. Check it out at www.irs.gov.

5) Write articles and include contact information for resources that relate to your topic. When you ask permission from your resources to include them, you've got their attention. Here's where

you combine networking with marketing. Offer to send them a copy of the article when completed, and then notify them when it is published. You can submit your article to online content sources, discussed in tip #4 in Chapter 8, or you can submit your article for publication in the local paper or in an organization's newsletter. What could happen as a result of promoting business or organizational resources may surprise you. For example, I've been asked about my coaching services and received an inquiry about booking a speaking engagement. Sometimes I use an interview format to spotlight a person whose business relates to mine. Writing this type of article works when you want to make connections with people you'd like to get to know or pull closer into your network. This doesn't have to be a major project; your articles can be brief (500 to 800 words). You will have created something that markets you and your resources. You will also be able to add the contacts for those resources to your network, and this is a quick way to network with people who may seem a little out of reach.

6) Blogs are great for getting your thoughts out there and for receiving information and other people's ideas. It's instant networking. Some of the most respected and popular business magazines produce annual lists of the best blogs on the Internet. Search with keywords like "best blogs" or "top ten blogs" to help you find links to such lists. These publications have done homework for you, and it's just a matter of making a quick trip to their site to pick out one or two blogs to investigate. Some popular women's networking organizations with Web sites offer blogs by topic in a more monitored environment to ensure appropriate communications. You can also find blogs that are companions to television networks, news or television shows, or popular magazines. A simple search should get you schooled up on blogs. Don't forget to check rules and etiquette. Then, start blogging.

7) Speaking of blogs, if you've got a Web site, you already have a vehicle for bringing networking opportunities to you. Consider incorporating some means of interaction on your own site. Blogs are easy to manage, and you can invite people to your blog by posting on other blogs. What I especially love about blogs is that you can conduct this form of networking any time of day or night.

It's instant mass communication. Check with your domain host or Web site designer for more information.

8) Your local Chamber of Commerce usually has a free Chamber membership directory. If it isn't free, it won't cost much and will be an invaluable reference for you. The online directory is useful, too, but the hard copy directory makes it easy to develop lists if you are doing promotional work. The directory should list members alphabetically and by category of business, with individual and/or self-employed people listed separately. Find the Chamber Member of the Year and the Small Business or Entrepreneur of the Year. Check out who sits on their Board of Directors, all of whom you should get to know because they are good networkers. But your Chamber's "Ambassador of the Year" should become your new best friend. Ambassadors are expected to show up at every Chamber event plus visit members to gather points toward awards.

9) When you enter networking events, apply an *ideal network* category to yourself that you believe fits. For instance, if you know that you are great at brainstorming marketing ideas, you are a "Marketing Brainstormer." If you are great at giving emotional support, then you are a "Supporter." If you love working with details, you are a "Project Manager" or a "Producer." When you meet new people, this gives you an instant platform from which to network, and the pressure is off you to "sell your business." Instead, you can look for situations where you can be of help. If you go into networking with this mind-set, connecting will be easier, which facilitates genuine relationship building.

10) Include me in your network. I'd love to know about your projects and networking ideas. You'll find my contact information on the Author page in this book.

I'm aware of how overwhelming it can feel when you are presented with so much information, so I'd like to recap The Ideal Network System in the form of a basic plan, so that if you haven't started yet, you'll be ready to roll.

THE IDEAL NETWORK SYSTEM PLAN

A) Organize your *ideal network*. Refer to Chapters 2 and 3.

B) Fill your network vacancies (concentrating on Connectors, Mentors, and Media). Refer to Chapter 4.

C) Pick two networking ideas from the list in Chapters 4 and 8. Book these ideas into your calendar so that you will take action on them.

D) Check into membership at your local Chamber of Commerce. Set up a meeting with the staff member responsible for membership to discuss you and your business or plans. Ask for contacts to people who could help you with your goals, and come away with every resource that you can. If you are already a member, review the Chamber Primer—Chapter 9.

E) Review the book again for resources and/or tips that you feel will be helpful. Circle the best ones and tag the pages. Book a day in your calendar to check out these resources.

F) Refer to Chapter 10 on maintaining your network, and review the "admin" items listed to do as routine. Go ahead and book them in your calendar as action items for the next couple of months, so they become fixed in your mind as a regular habit.

G) Give back. Become valuable in someone else's network. Look for an opportunity to mentor.

H) Do #10 in the list provided on the previous page. I want to be a member of your network.

Before I end this book, I want to tell you that I have no misgivings about being a creative person. I have absolutely no apologies for coming up with new ideas every other week, no regrets for trying what seems to make no sense to others, and no sympathy for people who don't have faith in me. I know who I am at heart, and what causes me to self- sabotage at times. I want to help you avoid some of the frustration that I went through.

The concept for this book originated in the year 2000. That's right—more than six years have passed since I initiated probably

one of the most meaningful projects of my life. In those years, I started a half-dozen other projects and changed career paths at least once. In fact, if you took a hard look at my entire work history, you'd find I was a business consultant, a cosmetics salesperson for a couple of years, was employed in three political campaigns, had staff positions in two international programs, spent a year as a program director, a few years in state employment, and a couple of years working for a financial institution. I'm laughing here—because there's actually more.

I'm a creative entrepreneur. I live for reinvention. Change doesn't scare me; "the same ole thing" scares me. The honest truth is, I was planning my escape not three years into the best full-time job I ever had. That should have been my big red flag. Sometimes our nature can present challenges that will put up roadblocks to achieving any real success. As much as anything, we want that success because it's not only important to us, but to those whom our success will impact. Since you've purchased this book, you, too, are looking for a way around your own challenges. I want you to find that success, quickly, easily, and without a detour that could throw you off-track for more than six years. I know for sure that asking and allowing the right people to help you make the best connections will make the difference. It has for me, and it will for you.

On this planet, we have every kind of resource—everything we need to survive and everything to attain our heart's desires. But, the greatest resource we have on earth is, and always will be, each other.

You have the power—you've had that all along. What you didn't have until now was The Ideal Network System. Go ahead; put that new "staff" to work for you!

Dear Reader:

This section is dedicated to those who shared their stories for your benefit. I offer their official introductions if you may wish to include them in **your** *Ideal Network*.

Best to you, Mary

Jay Conner, Composer and Pianist, CEO of Conner Properties

Jay invites you to check out his latest CD, "Romancing the Memories." If you live in the Carteret County, NC area and have a home you'd like to sell quickly, visit Jay's business site—www.jaybuyshousesfast.com. His music site is www.jayconner.com.

Tracy Williams, Professional Speaker, Consultant, Trainer, and Actor

Tracy is a former professional athlete who translates his entertaining energy into powerful messages to enlighten and inspire audiences across the nation. Tracy lives on the coast of NC. For booking information, visit www.tracywilliams.com.

Linda Staunch, CEO of Linda Staunch and Associates of New Bern, NC.

Linda is a busy public relations professional who has worked with Pepsi and Forbes Magazine, produced several retirement expos, and was a lead consultant on the largest event in NC coastal history. She also hosts the local television show "Around Town," now in its 8th season. Find out more about Linda at her site— www.lindastaunch.com.

A. L. Hamilton Nobles, Realtor®

Hamilton conducts business from his office in Atlantic Beach, NC. His specialty is primary residential, second homes and vacation investments in the coastal area. He can be contacted by e-mail at hamiltonnobles@yahoo.com.

Dr. Delena Kay Flakes, Author, Professional Speaker

Kay's areas of specialty are prison ministry, at-risk youth, and marriage and family issues. She has published several books and is available to provide her inspirational message to your audience. Kay lives in the Beaumont, TX area. Visit her site for details: www.delenaflakes.com.

Llew Ramsey and Elaine Main, The Selling Team Real Estate Agency

This top-producing real estate duo has become well known for their success in residential sales in coastal North Carolina. Based in the small resort community of Atlantic Beach, their offerings include private community and investment properties, commercial developments, and condos. You'll find listings and area information at www.thesellingteam.org.

The Ideal Network Club Members:

Martha Vaughan, CEO of VII Insurance and Investment Services and Registered Representative of Woodbury Financial Services.

Martha offers financial investment counseling and products for estate planning and protection of assets for individuals and business owners. Martha lives in eastern NC. Contact her for an evaluation by e-mail at vii_insurance_investments@earthlink.net.

Tressa Taylor, Designer & CEO of Taylored Interiors

Tressa offers residential and commercial interior design, full scale remodeling, and new construction, with an emphasis on creating spaces that function and are a reflection of the owner's style. Taylored Interiors is located in Morehead City, NC. Portfolio and more details at www.taylored-interiors.com

Julie Naegelen, Manager, Membership Services, Carteret County Chamber of Commerce

The Carteret County Chamber of Commerce (headquartered in Morehead City, NC) serves just under 1,000 business, non-profit, government, and individual members. The Chamber's Military and

Government Affairs Committees are quite active; and its Ambassadors Club and Leadership Carteret programs are always featured in the news. Visit their site for complete information and a membership directory. www.nccoastchamber.com

Debbie Fisher, Sales Director, Mary Kay Cosmetics, CEO of Office Fusion Solutions, Partner in Hyper International and Coastal Heritage Realty and Builders
Debbie's cosmetics business is worldwide, as she attracts clients and consultants from every state in the nation and across the globe. Hyper International is a business incubator in Morehead City, NC. Together with Office Fusion Solutions, the entrepreneur can experience a total package geared to meet their operational needs. As a Realtor®, Debbie can handle all of the details associated with buying, selling and, even constructing a home. Contact her by e-mail at dfisher1@ec.rr.com or visit her sites at www.marykay.com/dfisher, www.ncwelcome.com/ofs, and www.coastalheritage.com.

ABOUT MARY KUREK

Mary Kurek is a former Press Staff member for a North Carolina Governor and a Chamber of Commerce Executive Director. A graduate of Coach University and a certified Zenger Miller Corporate Facilitator, Kurek currently works as a Networking and Marketing Coach and Career Transition Expert.

Kurek's guest columns have appeared in the internationally recognized publication, _The Sporting News_ and a statewide film industry publication, _Reel Carolina Journal_. She is a regular contributor to NC Journal for Women, (one of the fastest growing online publications geared toward the interests of women in North Carolina.)

A graduate of the six-year U.S. Chamber of Commerce sponsored Institute for Organization Management and other leadership programs, Kurek is the founder of two model high school programs: Youth Leadership Havelock and Carteret Sports Leadership.

Kurek's own leadership role prompted her nomination in 1992 for Craven County Distinguished Woman of the Year, and later, a commendation from The Commanding General of Marine Corps Air Station, Cherry Point. Additionally, for three years Kurek produced and hosted a cable television show that aired twice weekly in Coastal North Carolina called "Dreamer's Showcase." The purpose of the show was to connect remarkable people who

were living their dreams with viewers in an inspiring and often interactive format.

Over the years, Kurek has been a featured guest on Sports Radio 570 KISM out of Utah and on WTKF Talk Radio in North Carolina. Her television appearances include network affiliates, WITN-TV and WCTI-TV in eastern North Carolina, as well as other community talk shows. Currently, Kurek produces a one-minute radio spot called "The Ideal Network Minute" on WTKF in Morehead City, NC, highlighting tips from *Who's Hiding in Your Address Book?*

Kurek and her husband make their home in the small island community of Atlantic Beach, North Carolina.

Kurek's Web sites: www.marykurek.com
 www.theidealnetworksystem.com
 www.resumehowtoguide.com
 mary@marykurek.com

How Your Chamber of Commerce Can Make Money with This Book

- Start an Ideal Network Club as featured in Chapter 5 of the book and modeled by Carteret County Chamber of Commerce, Morehead City, NC. This operates similarly to your Leadership Program, Military Affairs Committee, or any other fee-based group you organize for your members, and could add $2,000 or more in income. You'll have access to materials, training, and benefits for Chamber participants, like free membership into the Master Club, free Quick-Start Teleseminars, and discounts on other products and services produced by Mary Kurek. You will include the cost of the book in the fee you charge for Club membership. Pre-purchase the books using the order form on the next page (at a special discount arranged by my publisher), so you won't have to wait to begin organizing your **Ideal Network Club**. Get started now by checking out the information at **www.theidealnetworksystem.com** and registering for your free Operating Guide.

- Add the book to your new membership package and charge a little extra. You have resell privileges. Since the book contains a free membership into the Ideal Network Master Club ($125 value), it makes a nice gift. Also, the Chamber Primer in Chapter 9 makes the book a real value for your members. Buy the books now, so that you'll have them hot off the press and ready to include in your new membership package. Buy at least 2 cases of books right now and receive a Free autographed copy from the author to be used for a raffle item or special prize at an event.

- The author, called *The Chamber Lady*, offers you a discount on her workshop and speaking fees. In addition, she will give you a gift certificate for a one-hour personal coaching session to raffle off at a workshop. Value of the gift certificate is $150. Workshop fees cover the cost of a book for each participant. Contact *The Chamber Lady* at **mary@marykurek.com** to discuss arrangements.

- Throw an Ideal Network Party. For those Chambers that don't want to add an ongoing Club, an Ideal Network Party is a fun and productive occasional event. A free party kit is available at **www.theidealnetworksystem.com**. Charge a fee for the party that includes the book. Use the order form on the next page.

- If you operate a Leadership Program or Ambassador's Club, recruit (a) sponsor(s) (office supply stores, book stores, computer stores, or wireless providers are good ideas), and add the book to each participant's program materials with discount coupons and/or a promotional letter from the sponsor. Include the cost of the books in the sponsorship. Invite the sponsor to hand out the books at a program event. Order your books on the next page.

- Create a *Business Kit* for self-employed business owners or independent sales types, include the book, and sell the kit to this sector of your membership. Charge extra for non members.

- Your own idea:

_____.

Contact *The Chamber Lady* about your idea today.
mary@marykurek.com

ROBERT D. REED PUBLISHERS ORDER FORM

Call in your order for fast service and quantity discounts

(541) 347- 9882

OR order on-line at **www.rdrpublishers.com** _using PayPal._

OR order by mail: Make a copy of this form; enclose payment information:

Robert D. Reed Publishers
1380 Face Rock Drive, Bandon, OR 97411

Note: Shipping is $3.50 1st book + $1 for each additional book.

Send indicated books to:

Name _____

Address_____

City _____State _____Zip_____

Phone _____Fax_____Cell _____

E-Mail _____

Payment by check /_/ or credit card /_/ _(All major credit cards are accepted.)_

Name on card _____

Card Number _____

Exp. Date_____Last 3-Digit number on back of card _____

Qty.

Who's Hiding in Your Address Book?
Introducing _The Ideal Network_ for Successful Women
by Mary Kurek .$12.95 _____

Ten Commitments for Women
by Susanne Blake .$11.95 _____

100 Ways to Create Wealth
by Steve Chandler & Sam Beckford$11.95 _____

The Joy of Selling
by Steve Chandler. .$11.95 _____

Customer Astonishment: 10 Secrets to World-Class Customer Care
by Darby Checketts .$14.95 _____

The Midlife Bible: A Woman's Survival Guide
by Michael P. Goodman, M.D..$17.95 _____

The Coming Widow Boom: What You and Your Loved Ones
Can Do to Prepare for the _Unthinkable_
by James F. (Buddy) Thomas, Jr..$14.95 _____

Other book title(s) from website:

_____ $ _____

_____ $ _____